NEW VISIONS
IN
Celtic Art

D0745384

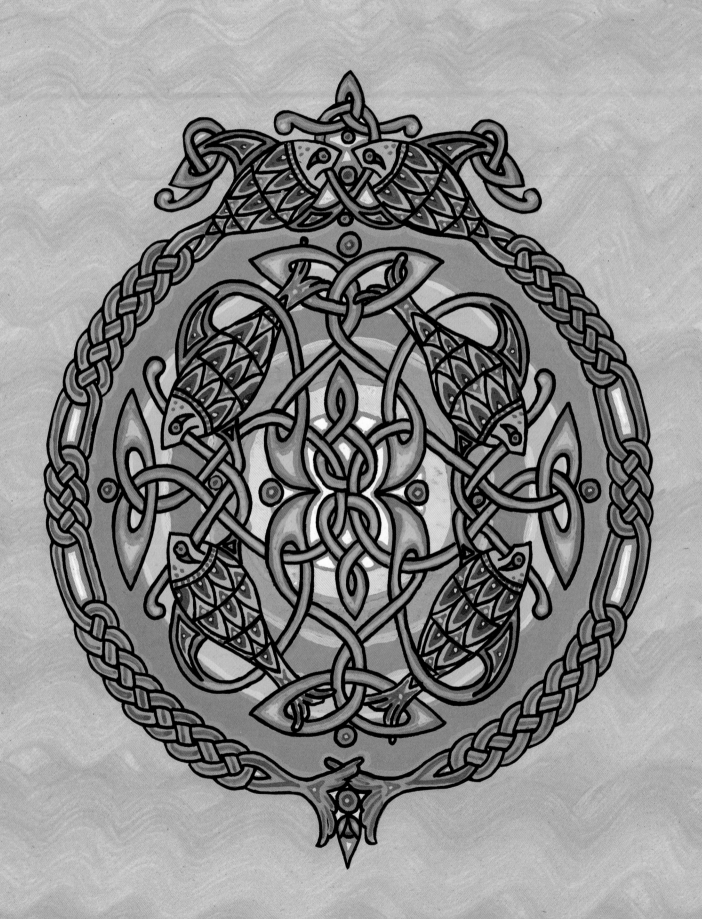

NEW VISIONS
IN
Celtic Art

THE MODERN TRADITION

Edited by

DAVID JAMES

and **STUART BOOTH**

BLANDFORD

N5925
.N48
1999

A BLANDFORD BOOK
First published in the UK 1999 by Blandford
A Cassell Imprint
Cassell plc
Wellington House
125 Strand
London WC2R 0BB

Compilation and design © 1999 Cassell plc
Introduction copyright © 1999 David James
All other texts copyright © individually named artists 1999
All designs and illustrations are original works and each is copyright © 1999
by the individually named and identified artists.

All rights reserved, no part of this book may be reproduced or transmitted in
any form or by any means, electronic or mechanical, including photocopying,
recording or any information storage and retrieval system, without permission
in writing from the copyright holder and publisher.

The publisher will permit and allow the use by individual persons only and for
strictly non-commercial use of applications the reproduction from the work of no
more than two items of design or illustration or artwork. All other use reproduc-
tion is subject strictly to the terms and conditions stipulated immediately above.

A Cataloguing-in-Publication Data entry for this title is available from the
British Library

ISBN 0-7137-2736-5

Designed by Chris Bell
Colour origination by Reed Digital, Ipswich, Suffolk
Printed by Dah Hua Printing Press Co. Ltd., Hong Kong

Frontispiece 'Pisces Celtica', and contents page 'Birds of Paradise' by David James

Contents

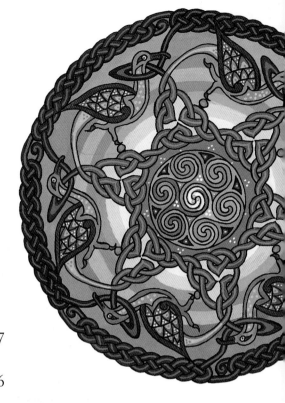

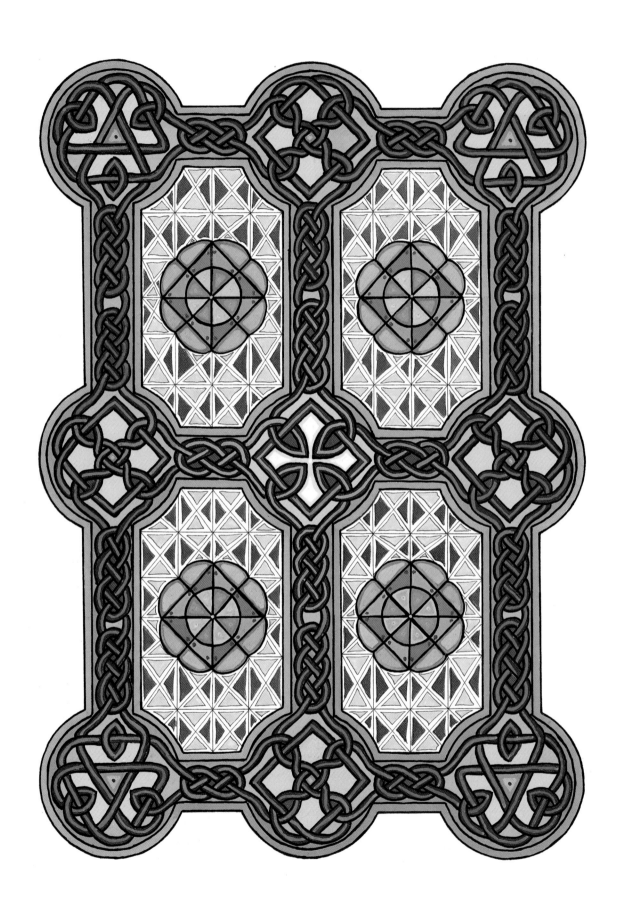

Introduction

BY DAVID JAMES

I T IS a great privilege to be asked to write the introduction to such an illustrious and varied collection of contemporary Celtic artwork. The illustrations in this book have been created in locations as far apart as the UK, Ireland and the USA, and reflect the extremely high standard of work now being produced worldwide in this field. For myself, I am no stranger to Celtic art, having received my initial exposure to this wonderful artform over 30 years ago, through the carvings on the island of Iona in the inner Hebrides. It was here that I spent a winter working with the Iona Community when I was 18 years old. Since then I have lived in different regions of Scotland, mainly on the west coast, and later in the heart of west Wales, where my intense involvement with creating Celtic art continued to grow.

I now live and work in an area of southern Britain, and my work includes writing books about the Celts, as well as creating Celtic paintings and editing a Celtic magazine. I am occasionally asked why my work is carried out in a region where there are no apparent Celtic connections. However, the south of Britain was in fact inhabited by a number of Iron Age Celtic tribes – from the *Dumnonii*, who occupied parts of what are now Cornwall and Devon, to the *Cantiaci*, whose territory included much of Kent and the Isle of Sheppey. The particular area of

OPPOSITE
VINE'S SONG

Dorset where I now live was inhabited by the *Durotriges* tribe. Celtic tribes established their territories throughout southern Britain during the first millennium BC, and remained there until they were ousted by the Roman invasions of the first century AD.

In 1994, soon after moving to this area, I established a vegetable garden, and I uncovered some attractive decorated fragments of Romano-British 'blackware' pottery in the freshly turned soil. These were dated by the local museum as being from the third and fourth centuries AD, and would have been locally made and fired by the descendants of the Iron Age Celts. Subsequently shards dating to the Late Bronze Age have been found here, indicating continuous occupation of this site for almost 3,000 years. Several years ago, a fine bronze mirror in the La Tène style of the first century BC was discovered about a quarter of a mile away from my home on a remote ridge. All going to show that the Celtic presence is still very much felt in this area.

Over the many years in which I have been involved enthusiastically in Celtic art, I have made the acquaintance of a number of talented artists whose work I very much admire and respect. In 1992, I founded the magazine *Celtic Connections*, which, during the six years that it has been running, has attracted many artists who have sent work for inclusion in its pages. The variety of styles and influences, together with the very high standard of work, gave rise to the idea of becoming involved in a project suggested by Stuart Booth, consultant editor for the Blandford imprint of Cassell, who also receives high quality artwork from many artists, as a result of his own dedicated publishing programme in the subject, and his strong affinity with Celtic art. It resulted in the compilation of this book, which contains representative examples of some of the best Celtic artwork available, in both colour and black and white, along with some thoughts by the artists themselves on their work.

Although this artform has continued in an unbroken tradition in some of the Celtic countries, especially Ireland, its modern revival in a major way began at the end of the last century. In 1904, J. Romilly Allen, a widely travelled historian and avid enthusiast of the

various forms of Celtic art, from the early European La Tène style to the later Irish and related Celtic Christian styles, produced his ground-breaking book *Celtic Art in Pagan and Christian Times*. This was the first attempt to classify and categorize the various styles of Celtic art that have been found on carvings and artefacts and in early manuscripts in Britain and Ireland. It contained a number of excellent line-drawings, designs and early photographs hitherto unavailable to the general public, and was a treasure trove of inspiration for the Celtic art enthusiast. (The book has been reprinted by Bracken Books, London, 1993).

Not so long after the publication of Romilly Allen's book, George Bain, without doubt the best known Celtic artist of this century and certainly the person who has made the most significant contribution to the renaissance of the artform, began his work. Totally dedicated, he worked for many years, much of the time 'on site', sketching with meticulous accuracy many of the ancient carved Celtic and Pictish stones of Scotland, as well as carrying out in-depth research into the design work of the early illuminated manuscripts, such as the books of Kells, Lindisfarne, Durrow and Armagh, and other less known Celtic Christian manuscripts, such as the *Lichfield Gospels* and the Irish *Gospels of MacRegol*. Bain's work was initially published as a series of small 'how-to-do-it' softback books, and were used in Scottish schools. Each book covered one particular facet of the artform: the construction of knot-work, spirals, key patterns, and so on. The influence exerted by these books on the general public, as well as school children, surprised even Bain himself, who received letters of appreciation from all around the world for his innovative work.

After his death, Bain's books were combined into a single volume, along with further unpublished material completed during his lifetime. This book was published as *Celtic Art – The Methods of Construction* (Macmillan, 1951), and for many artists and craftsworkers it is still the ultimate reference work, showing how to create a myriad of new and original designs using the appropriate geometric principles, which had been implemented by the Irish monks from the seventh century onwards. Bain, over a thousand years later, was the first artist to fully

re-evaluate these ancient methods of construction, and to provide many examples of each type in book form, for the enjoyment and inspiration of all.

During the 1960s and 1970s, more and more artists, myself included, continued to explore the Celtic artform, and many of us have at some point experimented with the methods laid out in Bain's book. Some extremely fine artists emerged during this period to carry the artform forwards, each adding their own unique contribution to the Celtic world. Some were influenced by the early European La Tène designs, or by images from the great illuminated gospels, such as the *Book of Kells*. Others began to produce artwork which included visionary depictions of characters from the Celtic myths and legends.

THE ORIGINS OF CELTIC ART

Because we tend to use the term 'Celtic art' in a general way these days, it is appropriate at this point to elaborate further on the different origins of the two main early Celtic art styles: La Tène and Celtic Christian.

The early La Tène style of art is said to have begun in the Hallstatt region of Austria in around the fifth century BC, or possibly earlier. La Tène itself was a Celtic lakeside settlement in what is now Switzerland, and was located beside Lake Neuchâtel. The Celts were tribal by nature, as well as being of flamboyant character and aggressively warlike. They were masters of horsemanship and the horse-drawn chariot, as well as being highly skilled craftsworkers and designers. Many of their objects of daily use, from the well-known bronze mirrors, to horse and chariot decorations, were embellished with stylistically bold, swirling, curvilinear designs which form the basis of this early artform. They loved bright colours and this was reflected in the enamelwork of the time. The predominant colours used by the Celts in this craft were red and yellow, and items such as buckles and horse-harness decorations displaying these colours can be found in museums both in Britain and Europe.

OPPOSITE
SUN BIRDS

10

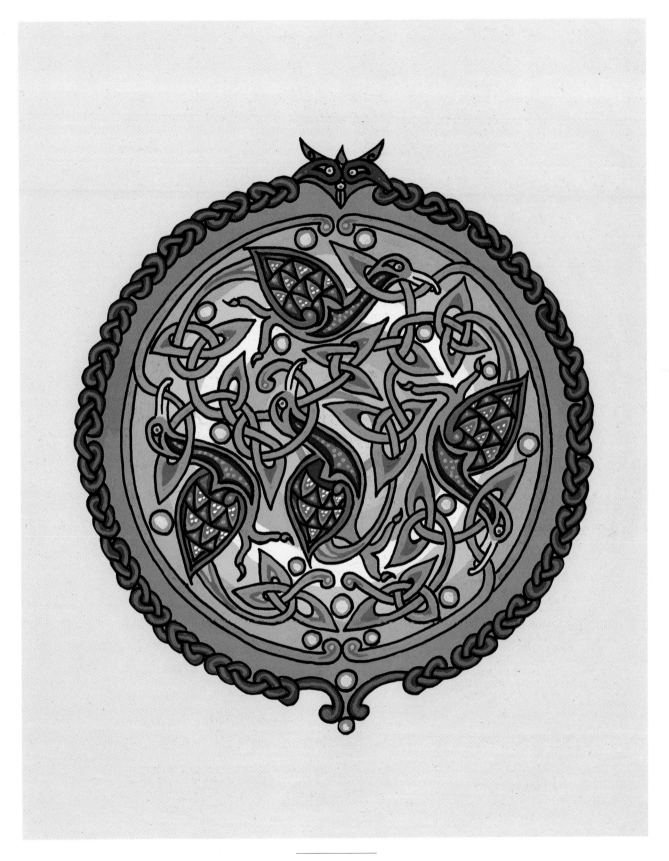

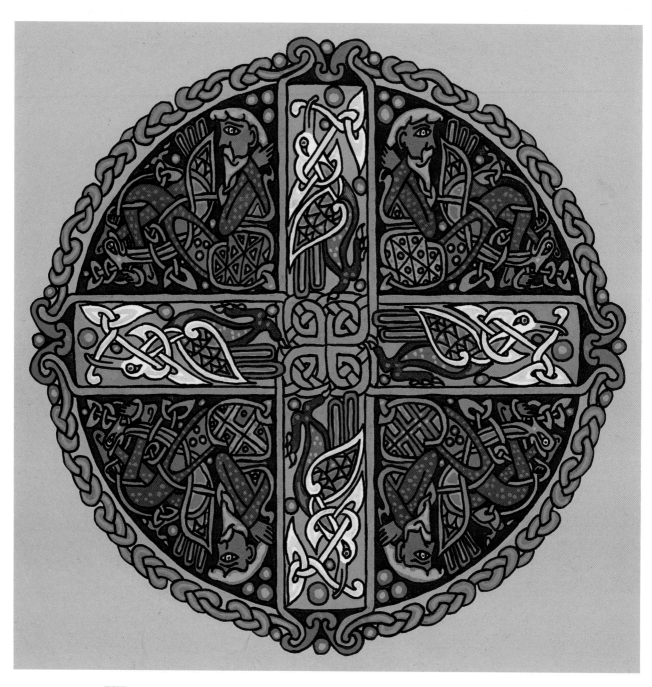

THE
MEDIATORS

Towards the end of the La Tène era, Celtic tribes began to produce their own coinage, much of which was made from gold. Coinage from any culture gives many clues as to the artistic nature of the peoples involved, and it can be seen from surviving coins of the late Iron Age Celts that sacred animals were very much a part of their art style. The horse, held sacred by the Celts, is frequently portrayed, and venerated, in the form of the horse-goddess Epona. Stylistic designs of the boar, wolf, bull and other 'power animals' also appear on coinage.

Some of the most complex La Tène designs appear on bronze horse-masks, known as *champfreins*. These skilfully made artefacts protected the animal's head when in battle, and were elaborately decorated with bold, swirling curves and curvilinear designs, as well as sometimes being inlaid with coloured enamel.

The era of Celtic Christian art begins from the late fourth century onwards within the Irish monastic communities. It is very likely that the art styles of several different cultures influenced the early Irish monks, including the indigenous artwork of early Ireland, which bears strong similarities to, and may well have had direct connections with, the La Tène style.

The peace and solitude of the monastic communities proved an ideal environment in which the monks could experiment and gradually perfect a magnificent and highly complex style, which during the seventh and eighth centuries gave rise to some of the finest artwork the world has ever seen. This artform can be divided loosely into five categories: knotwork; spirals; key patterns; anthropomorphic (including humans, birds and beasts); and calligraphic (the stylistic text in Latin around which many designs are carried out). To be proficient in any one of these disciplines took years of painstaking hard work, as well as a thorough knowledge of the highly complex geometric foundations on which the patterns are based.

This artform incorporated such a dynamic, almost explosive, spiritual energy that it could not be contained in one location, and soon found its way, via travelling monks, to Scotland, Northumbria, Wales, Cornwall, and southern Britain. Subsequently it was carried by intrepid

pilgrims overseas to Europe, certainly as far as Switzerland and Italy, where illuminated manuscripts from this period still exist.

Returning to this century, the development of Celtic art in the 1960s and 1970s gave rise to new and exciting books created by a few dedicated individuals, such as Jim Fitzpatrick in Ireland, the American Alice Rigan, who produced much of her earlier work while living in Morayshire, Scotland, and Aidan Meehan in Canada.

The Welsh-born artist, Courtney Davis, began his work during the 1970s, and has probably made the greatest single contribution to the appreciation of Celtic art over the last two decades. Courtney's work, which is now available worldwide, especially in many Blandford titles for Cassell, includes the *Celtic Art Source Book* (1988). He has produced many other fine publications, some of which he has illustrated in conjunction with writers on Celtic subjects, including *The Celtic Image* (Blandford, 1996), where my own text is illustrated throughout with Courtney's wonderful work.

Celtic designs have, since their inception, been an ideal adornment for all kinds of crafts. During the eighteenth century attempts were made to carve them onto freestanding church crosses. A few of these, where the sculptor had thoroughly researched the subject, display quality designs, though the majority are of a very mediocre standard. The function of the freestanding stone cross had also changed from being an important spiritual meeting place in Celtic Christian and medieval times, to that of a single burial-marker in a graveyard.

Nowadays, with the widespread resurgence of Celtic art, new and original designs as well as traditional ones can be found throughout the crafts world. These have been carried out on stone, wood, slate, leather, fabrics, glass, ceramics and jewellery, as well as painted or carved onto musical instruments such as harps and bodhrans. We celebrated the work of some of these contemporary craftsworkers in the pages of *Celtic Crafts – The Living Tradition* (Blandford, 1997), which included many fine colour photographs of Celtic designs applied to modern craftwork in a traditional Celtic style, as well as showing many of the craftsworkers and their locations.

The Celtic spirit is ever evolving. Recently, some very talented artists have emerged who are exploring new avenues of the artform. Just as each artist is an individual in his or her own right, so their artwork is equally unique, embodying personal visions and inspirations in tune with the Celtic tradition. The artists included in this book provide us with a fascinating overview of their work, and describe the main influences and inspirations which have, after much patience and years of hard work, resulted in superb illustrations, some of which can be seen here for the first time. It is hoped that *New Visions in Celtic Art* will be seen as a volume containing much beauty and inspiration, provided for us by individuals totally dedicated to expressing the aesthetic and spiritual essence which continues to emanate so strongly from the Celtic artform. ✖

David James
Editor, *Celtic Connections*
Dorset, UK, 1998

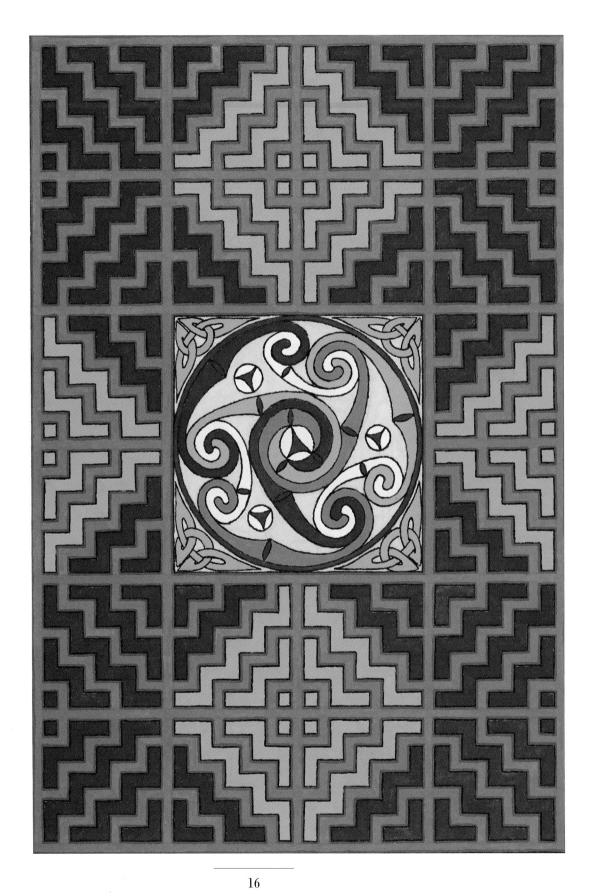

John Baker

BRIDPORT, DORSET, UK

I WAS BORN in the heart of West Dorset in the southern part of England in 1959, and have been there for most of my life. Both of my parents had Celtic blood, my father being half Scottish and my mother coming from a Manx succession. These blood lines appear to have intermingled and produced the inner inspiration that drives me onward in my quest for knowledge of all things Celtic, and so to produce my artwork. I live with my wife Geraldine and our two children, Nathaniel (twelve) and Rhiannon (five), not far from the place where I was born.

Traditional Celtic music has always been important to me, since I first heard it at an early age. I did not find Celtic art until later, but it was the discovery of this artform that seemed to inspire me naturally and led me to delve deeper. I read every book on Celtic art, literature and mythology that I could lay my hands on; it seemed that a fusion of influences had sparked a fire within me. It was about seven years ago that I decided to 'have a go' myself, first copying the artwork from the illuminated manuscripts, and then designing my own images.

So, after the fire of inspiration had been sparked into life, it grew into a blaze, until I was drawing at every opportunity I could find. However, a drawing was never complete until the colour had been

OPPOSITE
A STEP TO
THE PLACE
BEYOND

added. During the process of drawing, I found that the colours would shout at me from the page before I had finished. It was always these colours that would end up in the final picture.

I am never short of inspiration, only time. Inspiration comes from life. All I have to do is take a walk, look at the countryside or play some music, and something will appear to me pretty quickly. Images come to me often while I'm listening to music, reflecting the feelings and emotions that are bound up in my mind, and that just require a key to unlock them. When walking the ancient landscapes of Wessex near my home, I am struck how the Celtic people who once ruled here have left their spiritual, as well as the more obviously physical, marks on these lands.

Many of the pictures I produce are intended to be not only an interpretation of these inner thought processes, but also a key that I hope can be used by others to unlock and reveal the inner self. They not only reflect the emotions that pass through us all, but will also help us to tread the infinitely varied path of life. ❖

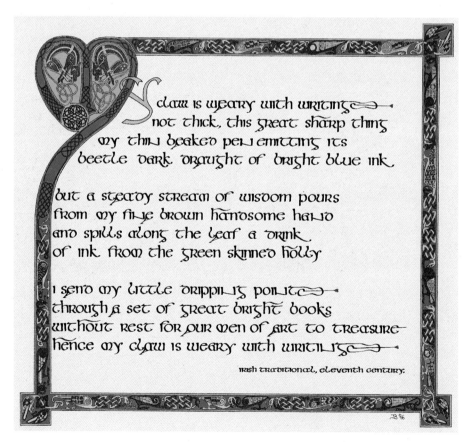

My claw is weary with writing
not thick, this great sharp thing
my thin beaked pen emitting its
beetle dark draught of bright blue ink.

But a steady stream of wisdom pours
from my fine brown handsome hand
and spills along the leaf a drink
of ink from the green skinned holly

I send my little dripping pointer
through a set of great bright books
without rest for our men of art to treasure
hence my claw is weary with writing

Irish traditional, eleventh century.

LEFT MY CLAW IS WEARY WITH WRITING. . . OPPOSITE ALCHEMAIC CONCATENATION

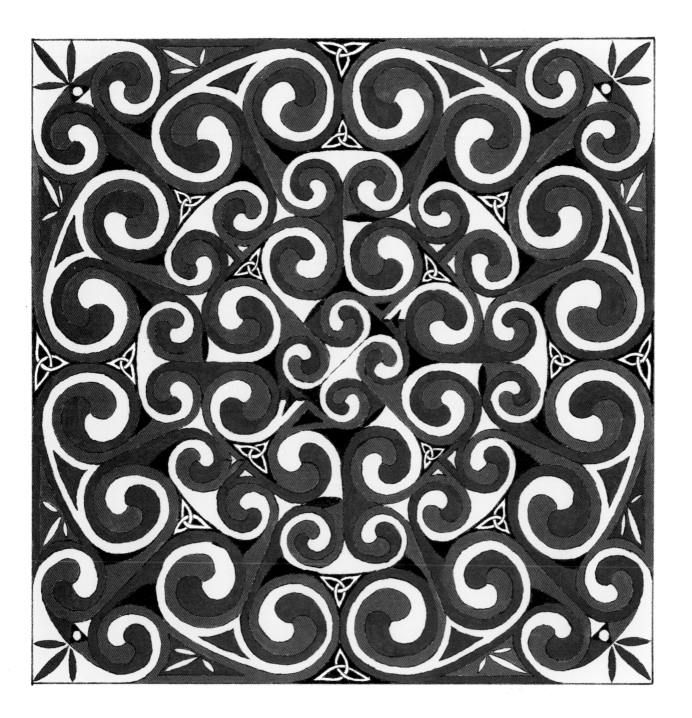

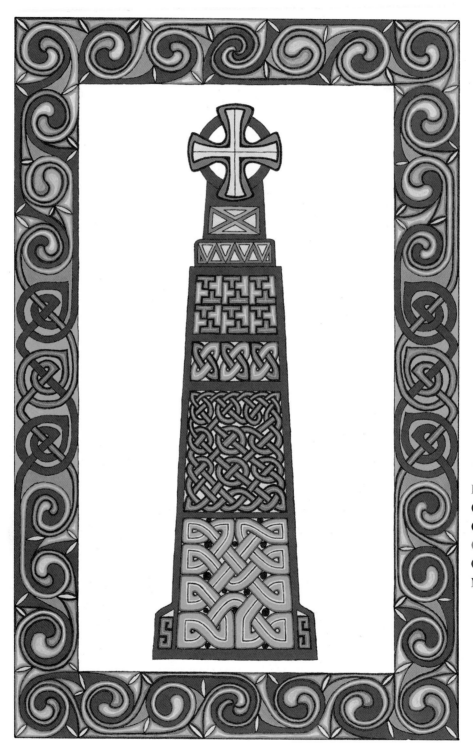

LEFT
CELTIC
CROSS I
OPPOSITE
CELTIC
MANDALA

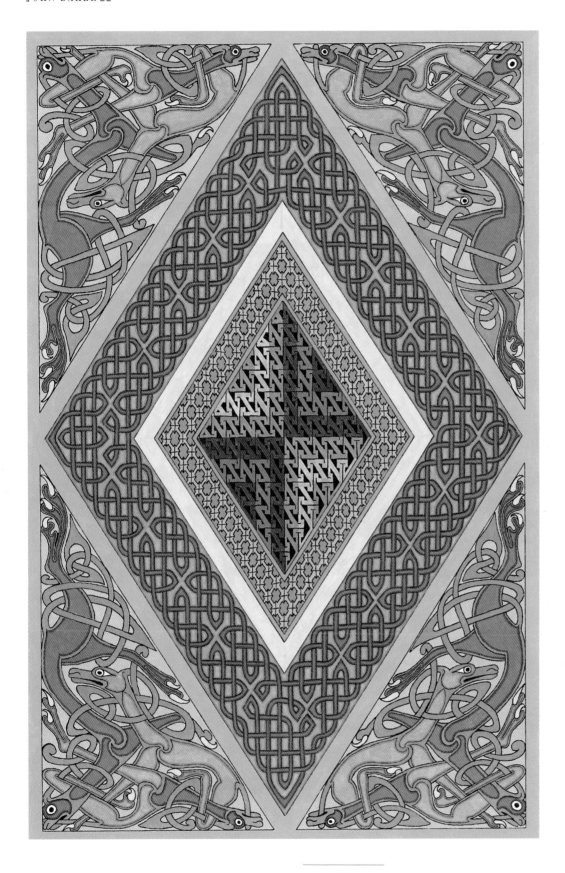

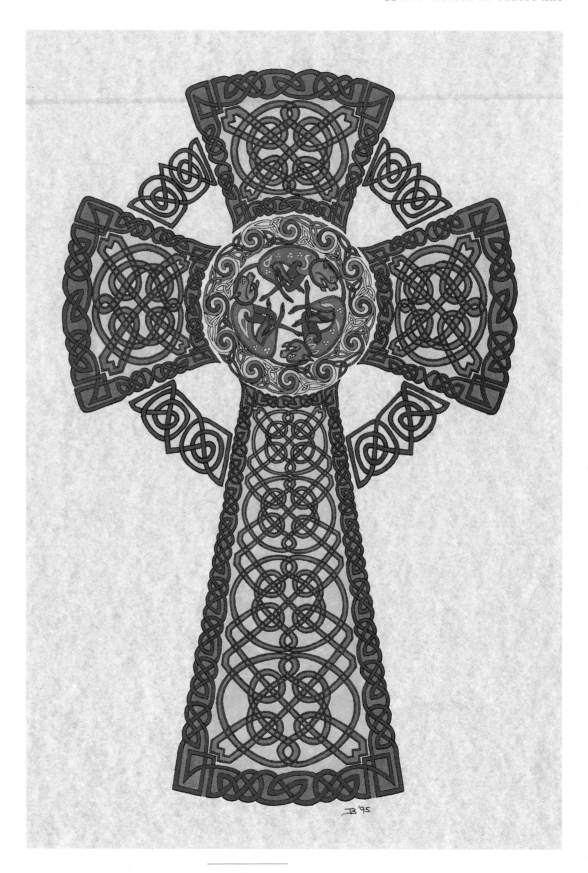

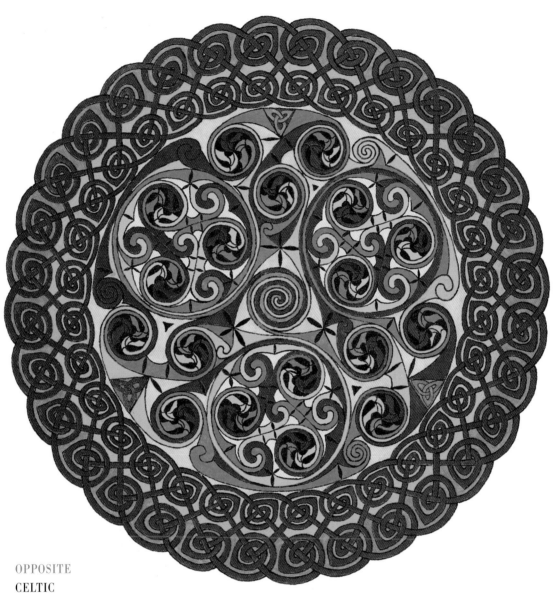

OPPOSITE
CELTIC
CROSS II
ABOVE
INSPIRAL
DREAMS

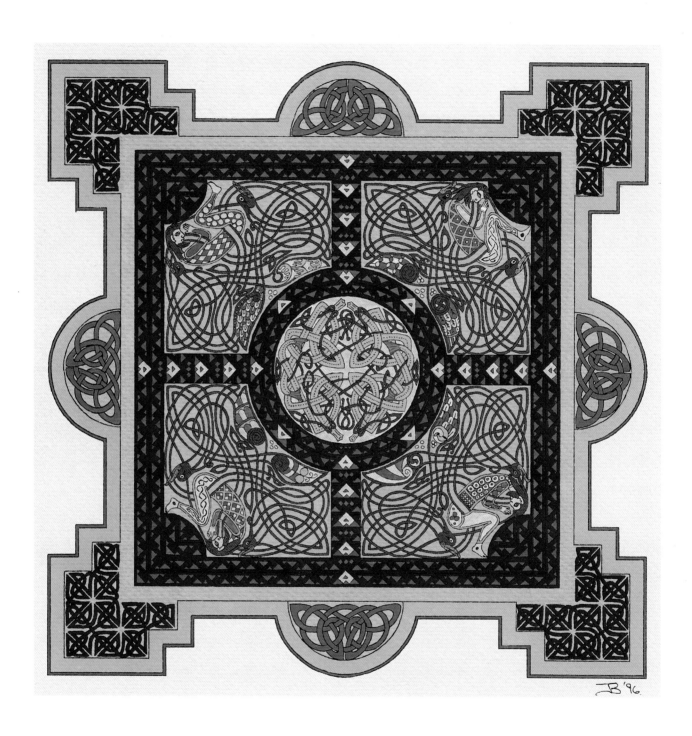

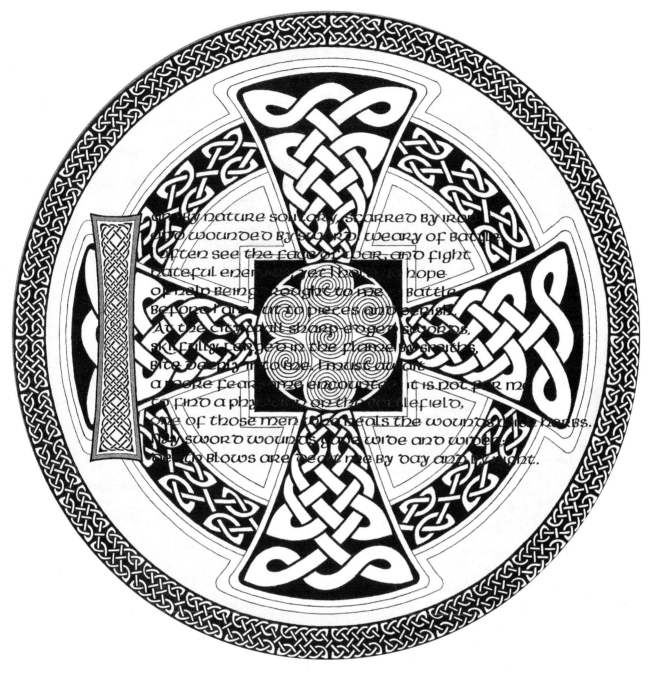

OPPOSITE
CARPET PAGE
ABOVE THE
SHIELD

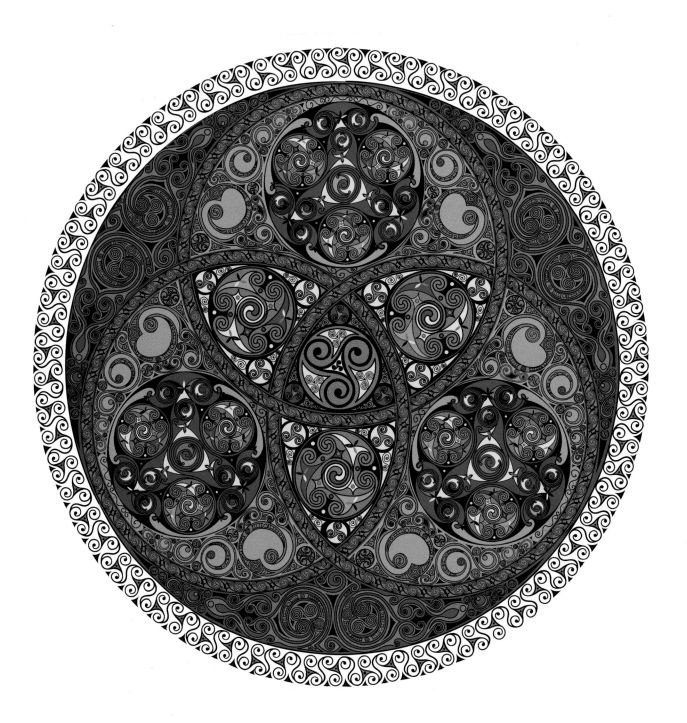

Jen Delyth

SAN FRANCISCO, CALIFORNIA, USA

I HAVE BEEN working with Celtic design for the last ten years in several media, including illustration, silk-screening prints and textiles, and, more recently, oil and acrylic painting. Apart from my personal connection of growing up in Wales, Celtic patterning resonates deeply for me philosophically and spiritually. I am interested in archetype, myth and symbol. As a language of psyche and soul, symbols, whether visual or in picture-words or traditional story-telling, can work as keys to an understanding of ourselves and of life. My imagination is filled with the colourful Celtic stories. By learning about the old ways I feel more connected to the earth.

Expression using a visual medium is more gratifying to me than using words. Creating beauty with symmetry and form is a source of great satisfaction. I love the clarity within the geometry, and the organic rhythmic curves of Celtic knotwork, there is a sense of profundity underlying the two-dimensional abstractions. Using this design language, I weave Celtic patterns into original designs which communicate the spiritual nature of the symbol. This work is a healing process for me: to learn and draw from the well-spring of knowledge of our ancestors, but to keep a fresh interpretation and expression. My approach is intuitive, but also pays homage to the Aois Dana – the inspired ones of

OPPOSITE
TRISKELION –
TRIPLE
GODDESS

27

Celtic tradition – who balance both wisdom of the intellect and knowledge of the senses.

Creating design involves both the discipline of form and the challenge of communicating specific ideas. At first, I explored the mandala circular form, focusing on combinations of threes and nines, the numbers of the Celtic female principle. The circle is organic, without beginning or end, and is the symbol of the goddess. A circular mandala frequently refers to the cyclic view of life, nature, fate and time, and mandalas are traditionally symbolic diagrams, often used for religious contemplation. For me, this was an intuitive choice, and I found it especially inspiring while working with Celtic knotwork designs.

I also enjoy using only black and white to express the central balancing principles of light and dark, intricacy and simplicity, mystery and clarity. As I introduced simple colour into the designs, I used symbolic shades, such as blue for compassion, green for earth, red for fire, and gold for spirit.

I have concentrated on the Celtic goddesses, who, although rarely depicted in ancient Celtic design for reasons of respect, form the heart of Celtic spirituality. Arianrhod, Rhiannon, Blodeuwedd and Cerridwen from the *Mabinogion* were natural subjects. I also chose the spirals, triskeles, and labyrinth (key-knot) motifs that are the organic patterning most closely related to the female earth-centred ancient world. 'The Tree of Life' was one of my first original designs, and this symbol, common to many world cultures, is an archetypal image especially relevant to the old Celtic religion.

I began with complex yet defined black and white drawings which complemented my sense of form and balance – ancient lines with a contemporary expression. This series of designs was carefully silk-screened onto hand-torn paper, serigraph prints, textiles and greeting cards. Learning to silk-screen images onto paper, creating serigraphs and producing limited runs of prints is always fascinating. Silk-screening is an ancient Japanese art, and, in the 1950s in California, was rediscovered as an exciting new way of working with images, soon gathering a strong following of artists. There is an inspired print-making community of

artists working in the San Francisco area, experimenting, creating prints, signing and matting small editions – each one an original in a way.

Each of the printed designs that I sell is accompanied by an explanation of the symbolism and mythology, which I carefully research and explore before publication. I hope the images communicate without words, but the stories and explanations behind the work are important also.

I feel fortunate that I am a self-taught artist. I have been free to explore and experiment using my intuition as my creative guide. My preferred way of learning is by immersion, by doing. I have no particular design method, and work with an image until I feel it is satisfying to me. Then I focus on line and symmetry to create a design that flows freely and with clarity.

I use a variety of tools and design aids, including pens and pencils, mixed media, and computers. I am open to using any material that sparks the creative process, and translates intuitive vision into a form that communicates. I have silk-screened images onto textiles that are not simply decorations, but hold a deeper meaning and relevance, both personally and within the Celtic spiritual tradition. I think it is important to reclaim the mystical aspect of image, especially in our over-commercial iconographic society.

I started our Celtic Designs crafts business in California, where I moved in the mid-1980s. My family, who still live in Wales, sell my work at local fairs, folk festivals and galleries, keeping my life and business truly international. Although I have, at times, felt the heavy heart of exile, I am more fortunate than the first settlers, in that I can return often to my family and home back in Wales, and they have also visited me here. My roots are stretched, but not broken, and my deepening interest in my cultural inheritance is more keen for moving far away. I live literally beyond the ninth wave of the home of my birth, as do many Welsh, Irish, Scottish, Cornish, Manx and Breton people. This migration seems to be our natural inclination, as it was with our Indo-European tribal ancestors who moved constantly westward, and were pushed by necessity to survive in the hilly, craggy, misty corners of

Europe, and then in modern times to travel in great waves across the sea to America.

I've been fortunate to make my living as a Celtic artist, and enjoy connecting with other creative people through this process. With my partner Scott's help, we have grown our small cottage industry crafts business into a professional company that sells our textiles, cards and silver jewellery to shops all over the world. I am currently working on a book which represents the collection of my work of the last ten years. ❖

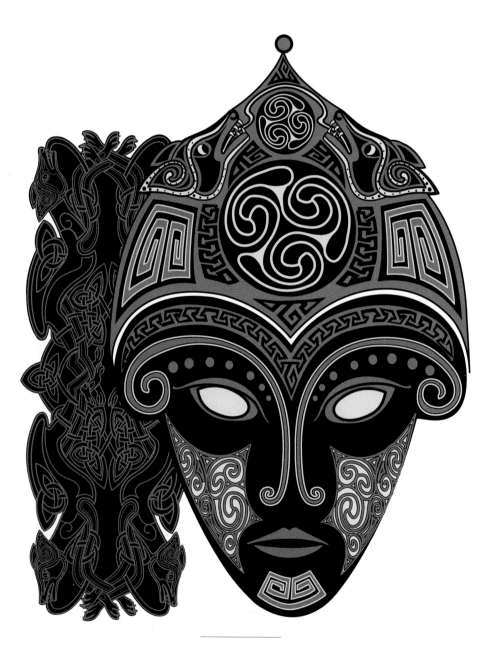

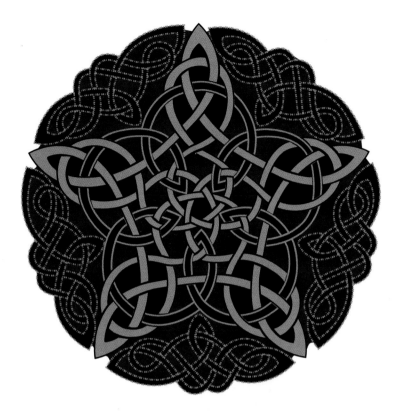

OPPOSITE
PWYLL –
LORD OF
ANNWN
ABOVE
PENTACLE
KNOT
RIGHT LLEU –
SHINING ONE

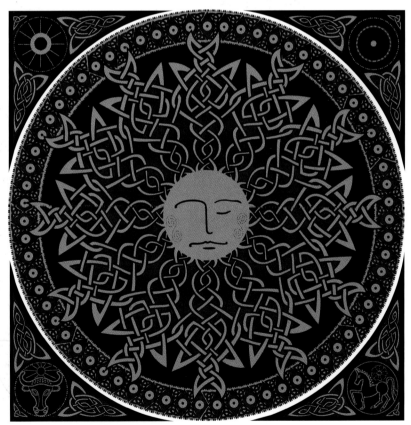

31

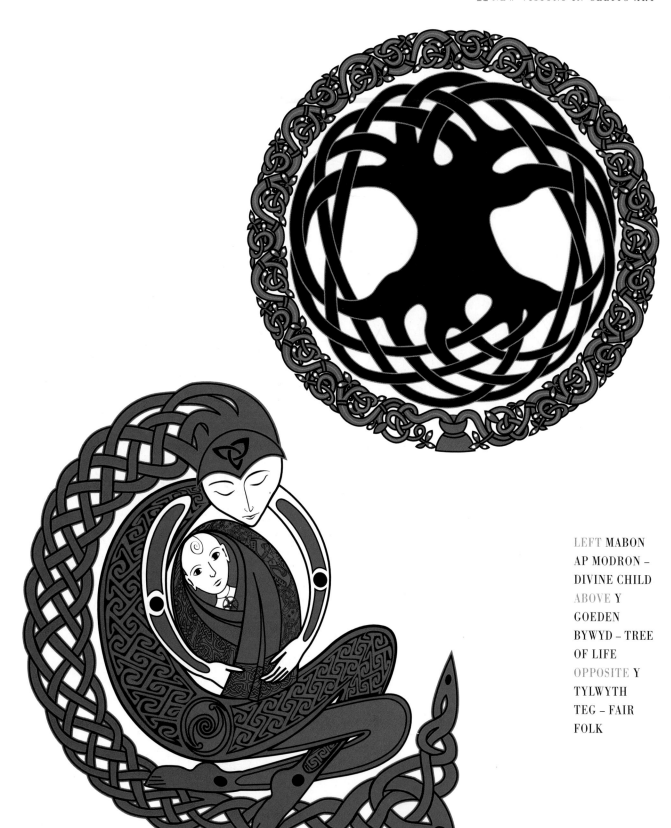

LEFT **MABON AP MODRON – DIVINE CHILD** ABOVE **Y GOEDEN BYWYD – TREE OF LIFE** OPPOSITE **Y TYLWYTH TEG – FAIR FOLK**

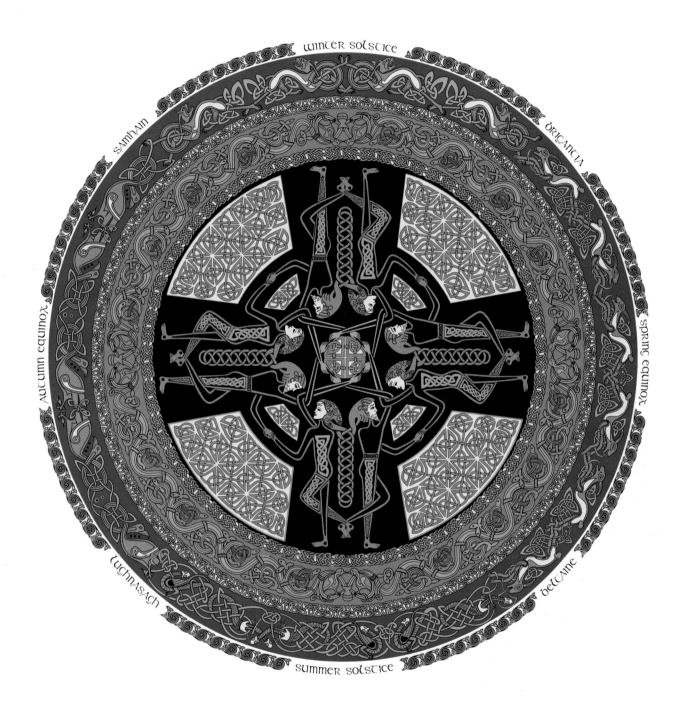

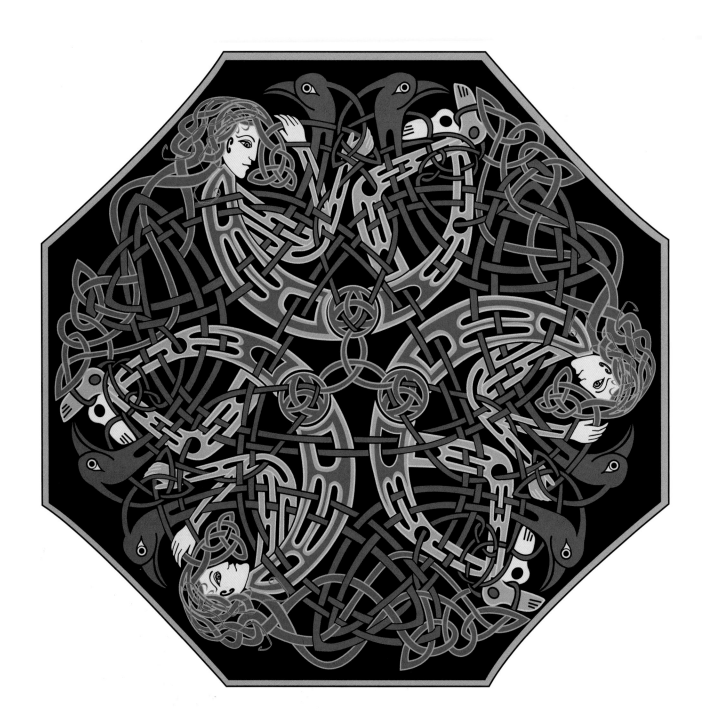

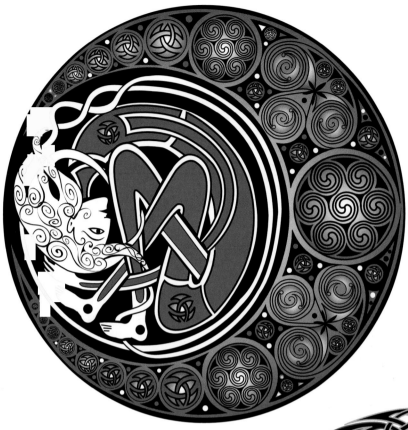

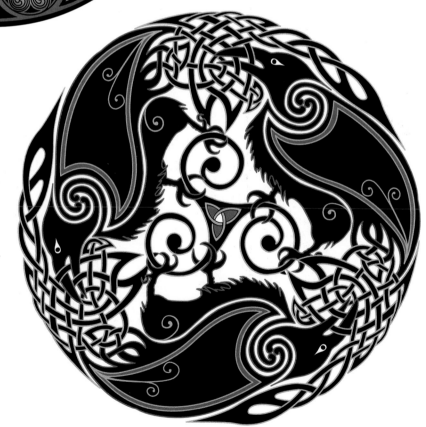

OPPOSITE
**BIRDS OF
RHIANNON**
ABOVE
**ARIANRHOD –
MOONSPIRIT**
RIGHT
**TRIPLE
MORRIGAN –
RAVENS**

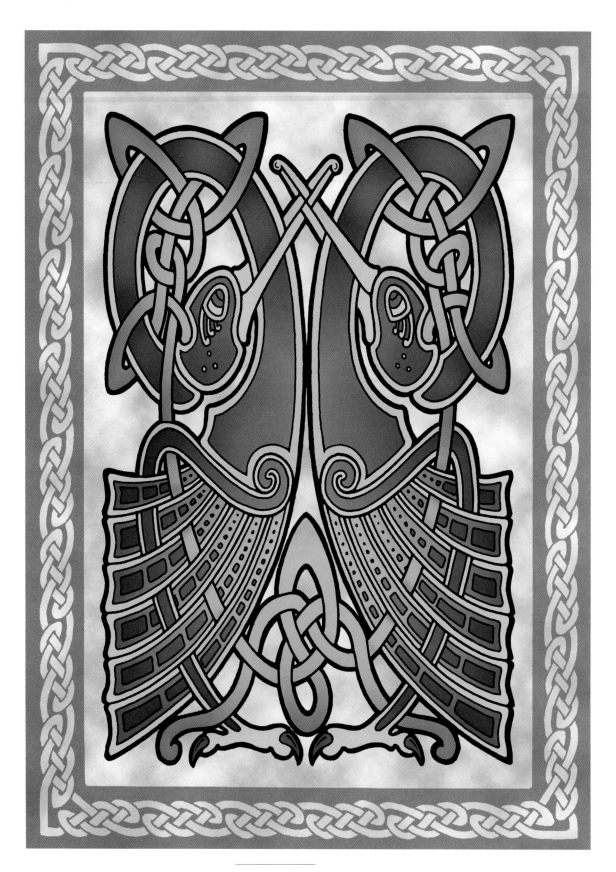

Chris Down

SALISBURY, WILTSHIRE, UK

WHEN I LOOK back on the last four years during which I have been working on Celtic designs, I am surprised at how much my approach and techniques have changed. When I first started to work seriously, to transfer work from a detailed sketch onto the finished item, I would be hunched over, a clear perspex sheet resting on my knees and a lamp shining through the design to trace it out. Before adding the final colour, I would have several photocopies made on card and would ink in different versions to see which looked best. Nowadays I scan a sketch into a computer, trace it out on screen, and create a potentially infinite number of colour fields before deciding on the finished result. It is all a far cry from the way the original illuminated manuscripts were created, but as far as I am concerned the techniques I have developed are an ideal way of approaching Celtic art for use in the printed form.

So far the one part of the process that I have not changed, and would not want to, is the sketching out of the original idea in pencil. I re-draw it as many times as it takes, making sure the image looks the way I want it. There is still much to be said for the use of pencil on paper, despite all the high-tech gadgetry at the modern designer's disposal.

OPPOSITE
TWO BIRDS

I made my first attempts at Celtic art some ten years ago, when I optimistically told a friend that I could paint some Celtic designs on his motorbike. The petrol tank, side-panels and mud-guards all needed doing, starting from bare metal, and the whole thing had to be finished within a week to be exhibited at a bike show. Just to add to things, I decided that I would apply some of the knots in gold leaf – I suppose I must like a challenge! Knowing nothing about knotwork, or how to design it, I based my designs on those from Jim Fitzpatrick's *The Book of Conquests* (Paper Tiger, 1978). Somehow it all seemed to work, and at the time I thought it looked alright – I'd probably feel differently now. From that moment on I decided that I could do knotwork. I couldn't of course, but you shouldn't shatter youthful illusions.

Later that summer I bought a copy of George Bain's book *Celtic Art – The Methods of Construction* (Macmillan, 1951). I have yet to meet anyone interested in Celtic knotwork who has not used this book at some point – it seems to be universal. Two years on, I bought Courtney Davis's *The Celtic Art Source Book* (Blandford, 1988). By now the three main influences on my early work – Fitzpatrick, Bain and Davis – were known to me, and over the next few years I continued to produce pieces sporadically, still innocently convinced I could do knotwork.

All this time, I earned my living as an architectural technician. This proved to be a very strong grounding, as it gave me a sense of geometry, layout and graphic drawing skills, all crucial for the bare bones of Celtic art, before the more ornate parts of the patterns are added. However, architectural drawings are nearly all straight lines which, after a while, become dull to do. Also, doing building surveys did not allow me any artistic input, as I had to draw what was there, and then pass it on to someone else to be creative.

It was the recession of the early 1990s that came to my rescue. Work dried up and I had a lot of time on my hands, an ideal opportunity for me to really prove that I could do knotwork. Many months locked away, drawing and redrawing, in a state of unemployment, was just what I needed. After this period of time, rather than thinking I could do knotwork, I actually could. From then on it was a progression

of practice, improving techniques and learning and developing new ways of recreating knots and spirals.

The two painted pieces I submitted for this collection represent one of those new ways. I wanted to get away from heavily line-based work for a while, and give the effect of knotwork carved in stone. Relying more on three-dimensional form and tone than on bounded shapes, and by building up the form in thin layers of paint, rather than relying on technical pens and coloured inks, was quite liberating. I have since gone on to experiment in ways of working like this with a computer, but at that time paint seemed the only way. Actually, it's good to have a single finished product, like a painting. For me, the major disadvantage of using the computer – as I now do for completing most of my work – is that an original piece as such is never created. It is only when it is properly printed that I know whether a design has really worked or not, something my home printer is not able to do. This certainly adds a sense of anticipation to the process, especially the bit of me that wonders how it will really look and whether my ideas will have worked. That is the universal pitfall of computers, useful as they are: there are a great many more ways in which everything can go horribly wrong on a computer compared with using traditional methods.

Why do I do it? Because I like patterns and the challenge of creating them. Even if no one else looked at them, I would still create these designs for myself. It is as simple as that. When it is right, Celtic art can be almost hypnotic. A pleasure to the creator as well as the viewer. It also allows many ways of approaching it, depending on the final usage. For the more simple pieces that I draw, the positioning and shape of each line is important and requires some thought. For the more complex pieces, individual lines no longer have that same importance, and it is the overall patterns that count. This is the case with a carpet page for the *Lindisfarne Gospels* that I once drew. I could not possibly spend the time on each line as I would over a single spiral. I did the carpet page to see if I could. Once again it was the challenge of producing something that was my reason for starting it, with no final output in mind. All the same, I never do straight copies, as I always need to put something of myself

into a design, to make some changes, however small, and put my own mark on the new version. I always have to reinterpret, even when redrawing one of my own pieces. The picture 'Dog Heads' (originally a small motif in the *Book of Kells*) is the fourth different version I have done of this image. Each one progresses further away from the original in the quest for a better image.

And as long as the challenge is still there, I will carry on. There are plenty more patterns and ways of going about Celtic art. I'd like to think that so far I have only scratched the surface and that there is much more to come. ✖

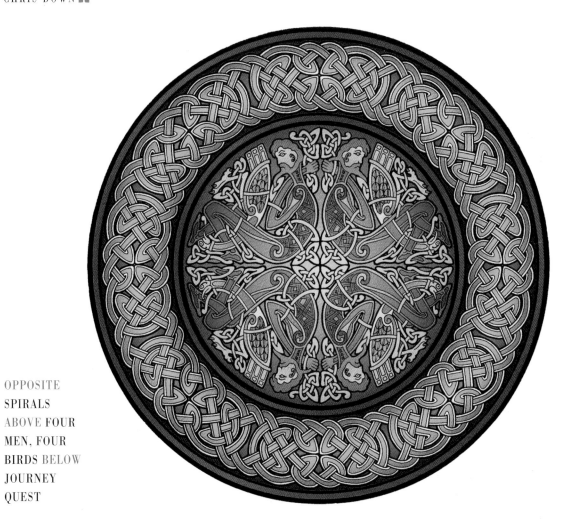

OPPOSITE
SPIRALS
ABOVE FOUR
MEN, FOUR
BIRDS BELOW
JOURNEY
QUEST

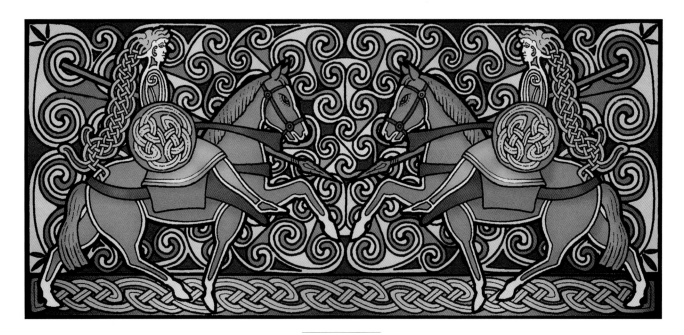

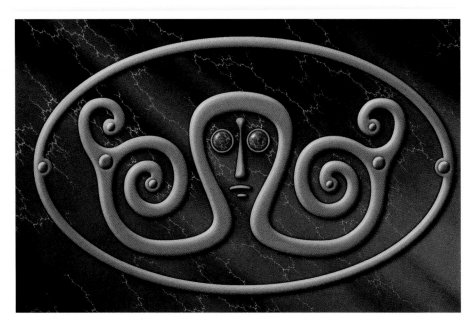

LEFT SPIRAL
HEAD BELOW
DRUIDS AND
VISION POETS
OPPOSITE
DEVENISH
HEAD COPY

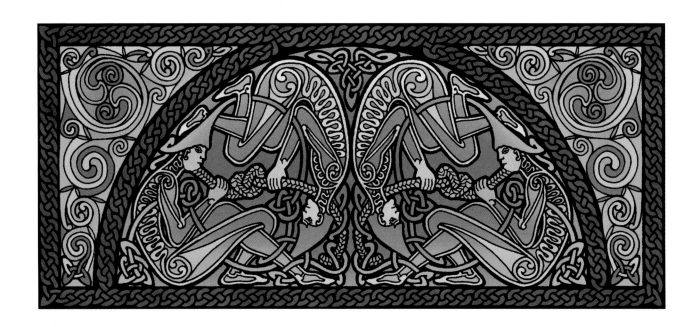

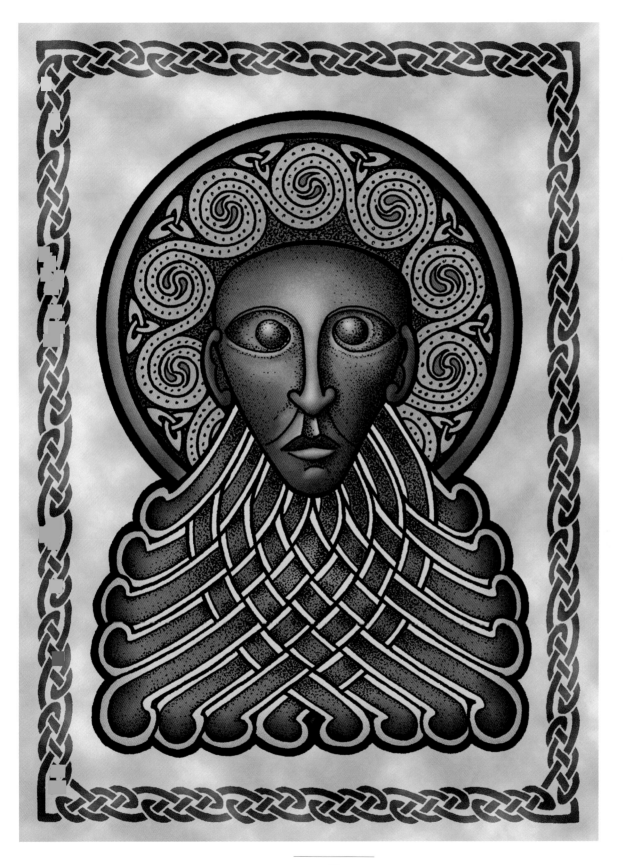

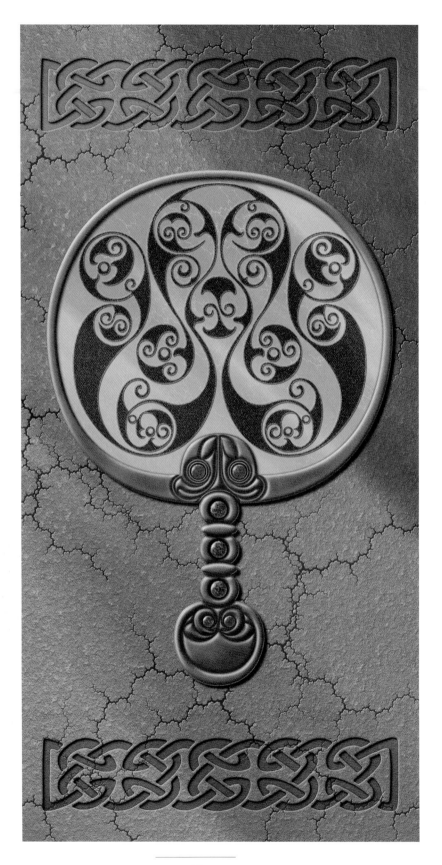

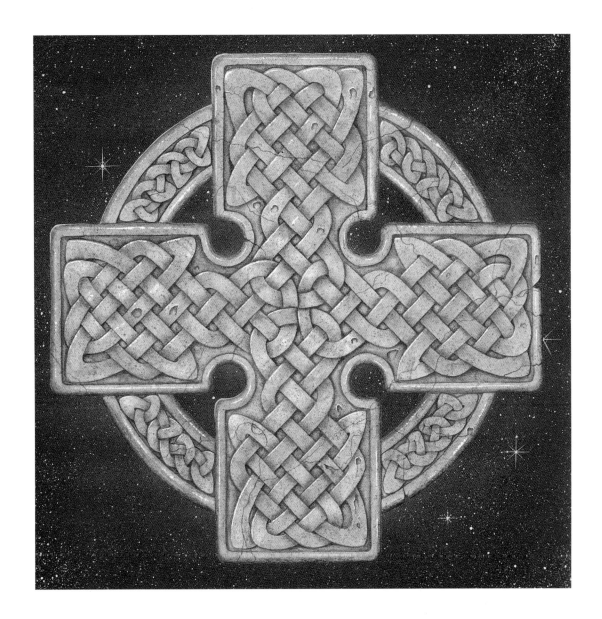

OPPOSITE
HOLCOMBE
MIRROR
ABOVE STONE
CROSS

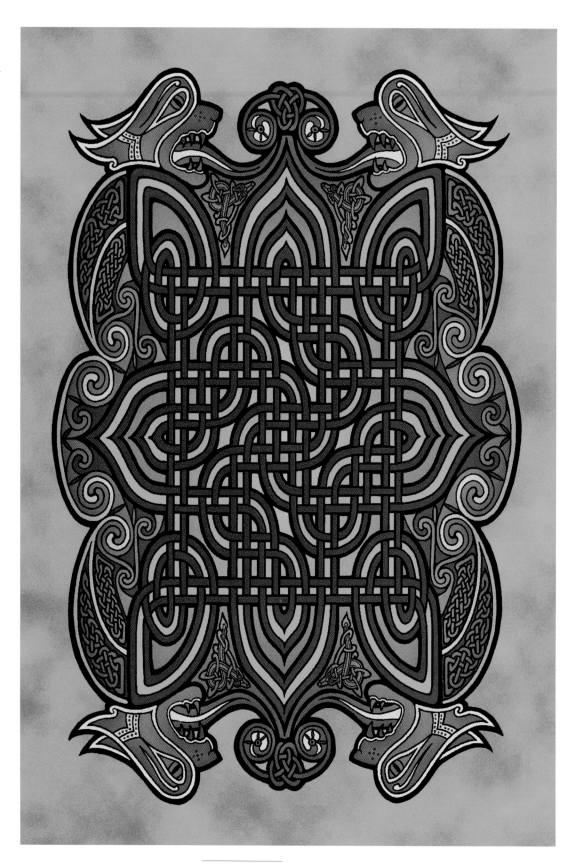

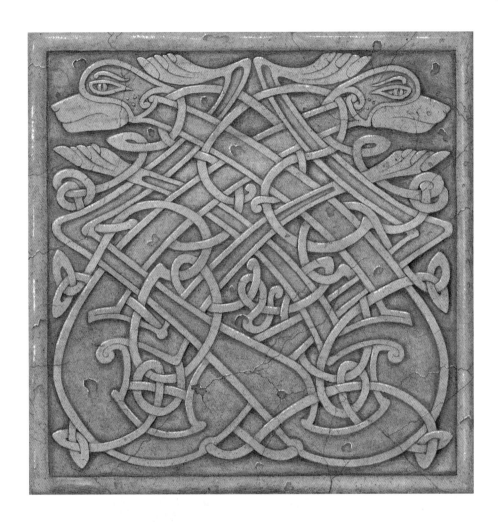

OPPOSITE
DOG HEADS
ABOVE STONE
DOGS

Fred Hageneder

STROUD, GLOUCESTERSHIRE, UK

NONE OF the 'barbaric' peoples of the North, whether Celtic or Teutonic, produced images or idols of their gods before the arrival of Roman 'civilization'. Although they depicted some figures, symbolizing forces of Nature, near holy wells, caves or sacred groves, the supreme deities and aspects of the Divine Source, were considered too transcendent, too ever-changing, too fluid and incomprehensible.

Equally vast and ever-changing is the *Wyrd*, to use an Anglo-Saxon term: the Web of Life that encompasses all, woven by the three Norns at the foot of the World Tree. Everything is connected and affects the rest, and each of us is a co-weaver in our own way. It is the web of interlacing energy fields that connects our world with the Otherworld and everything-there-is, and gives a deep spiritual meaning to artistic work based on patterns, whether it is musically in the cascading notes of a Celtic harp, or in the visual abun*dance* of the famous Celtic knotwork.

Celtic art has always been subject to external influence. Early Celtic craftsworkers decorated their pottery and metalwork with patterns that were derived from Near Eastern art. It is believed that the ancient Irish picked up the harp first from a passing Phoenician trading ship. The Celts were a people who were not too proud to exchange and

learn from others, but what they received they made unmistakably their own. In these cases, they transformed foreign art into authentic and, even more, *essential* expressions of the *spirit* of Celtic culture.

To be true to the spirit of our ancestors, we should not cling to any kind of rigid dogma of what is Celtic and what is not. The Spirit is as strong as it ever was, and it is the Spirit that counts, not the form that it takes. If our connection with the Spirit is strong, we will feel relaxed and move within the freedom of form. Just listening to the *Awen* – the divine inspiration – and practising our skills is enough. We do not need to look outside for what we *should* do, but we should look inside for what *needs* to be done. It is this approach that Wassily Kandinsky called 'inner necessity', the only true motivation for art.

I receive my inspiration from the sacred land, and my painting, drawing and harp-playing is a way of trying to give back some of the love that we all receive continually.

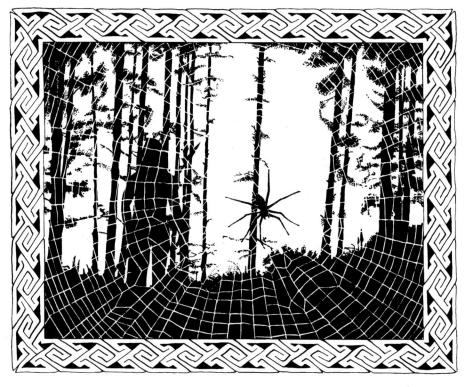

LEFT
SPIDERWEB
OPPOSITE
DRAGON
DANCE

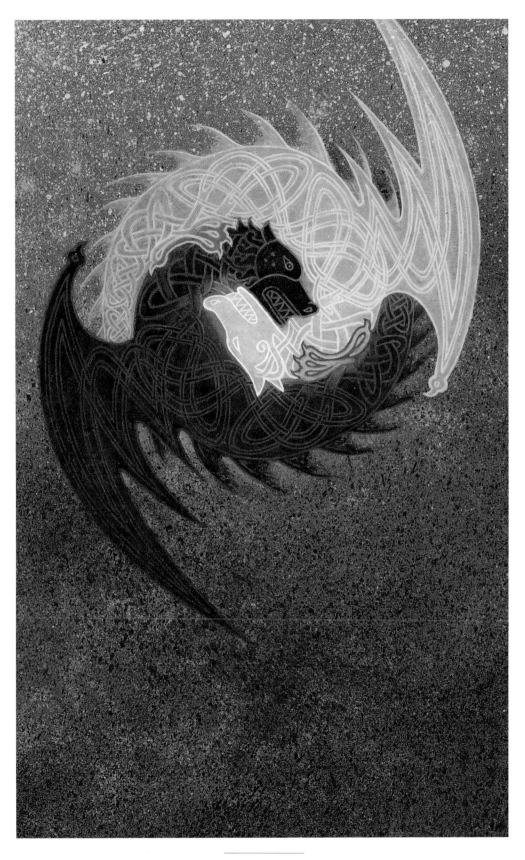

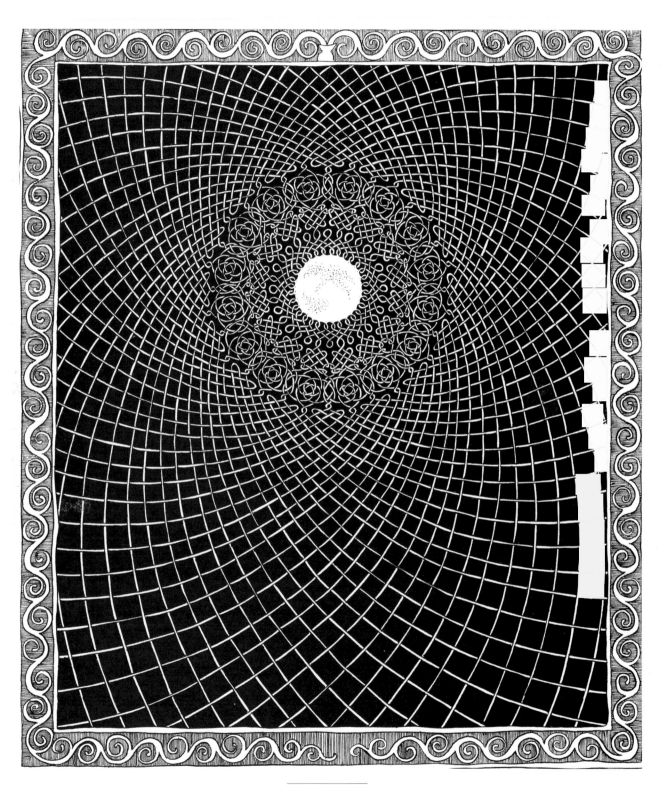

OPPOSITE
MOON LIGHT
ABOVE OLD
BEECH

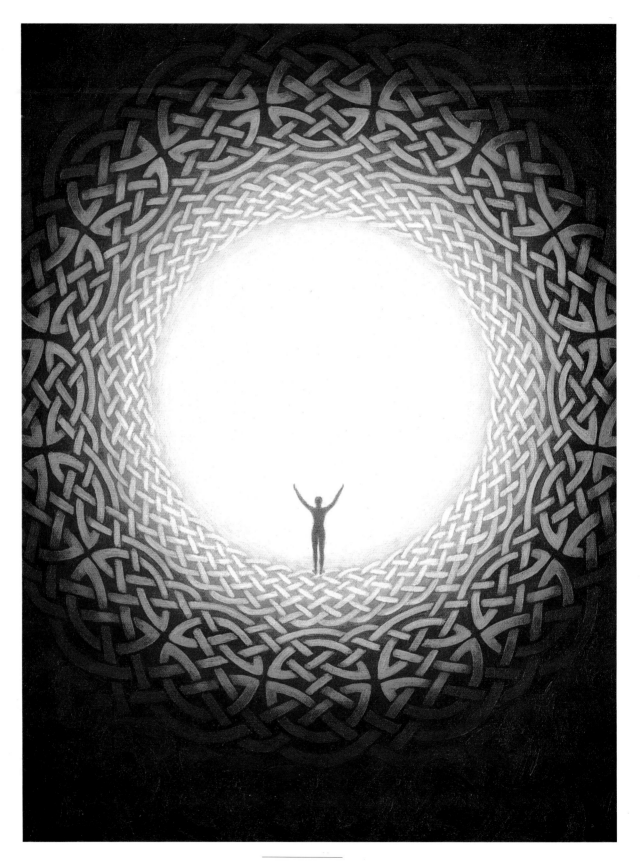

OPPOSITE
BIRTH OF A
NEW MOMENT
BELOW **TRUE**
BODY

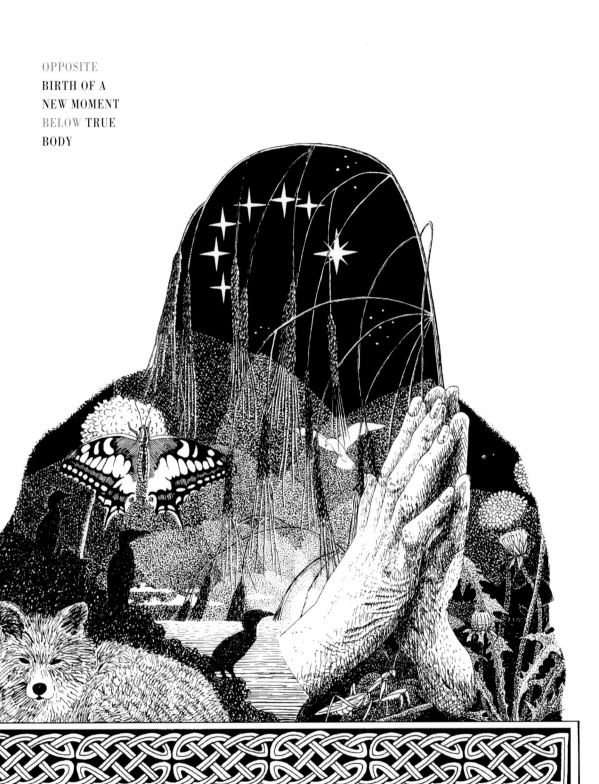

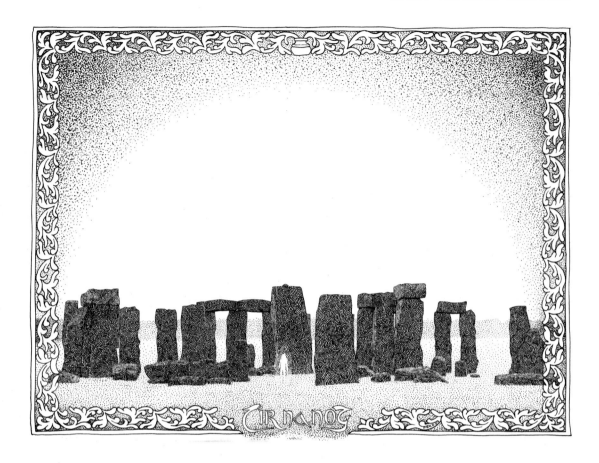

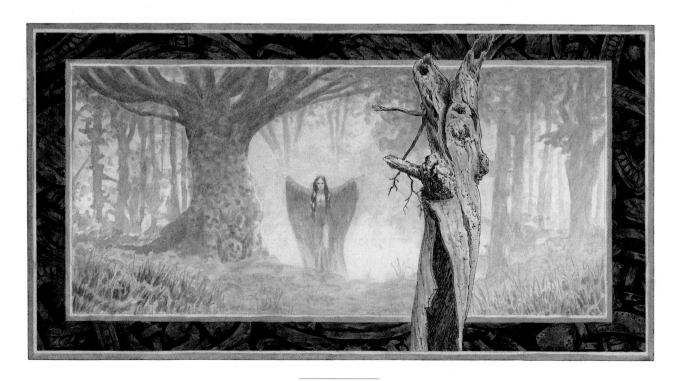

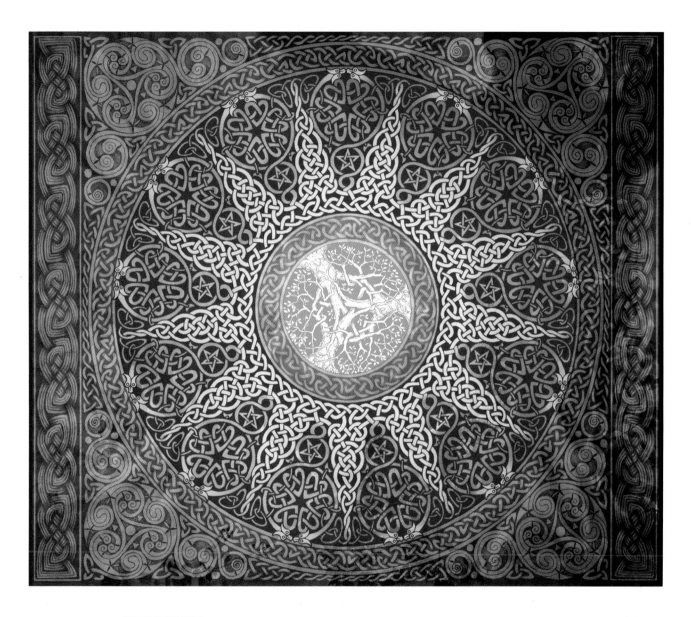

OPPOSITE TOP
TIR NAN OG
OPPOSITE
BOTTOM
ALDER WOMAN
ABOVE
TREENITY

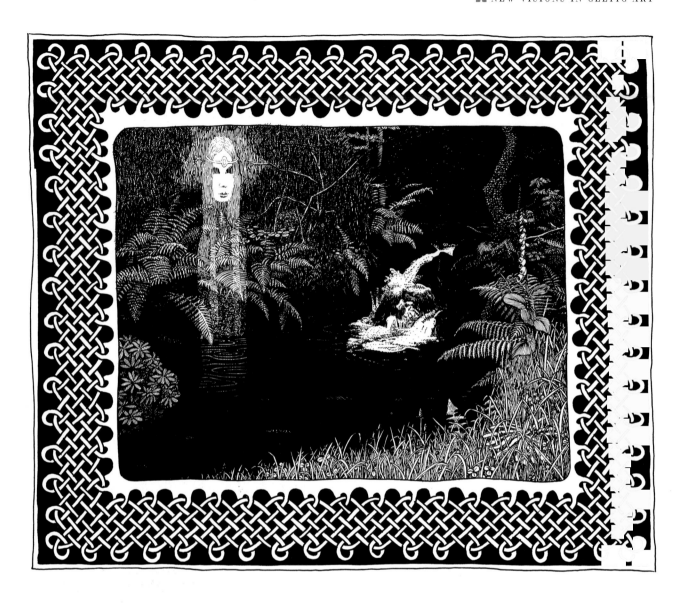

ABOVE WATER
NYMPH
OPPOSITE
WEAVING THE
FOREST

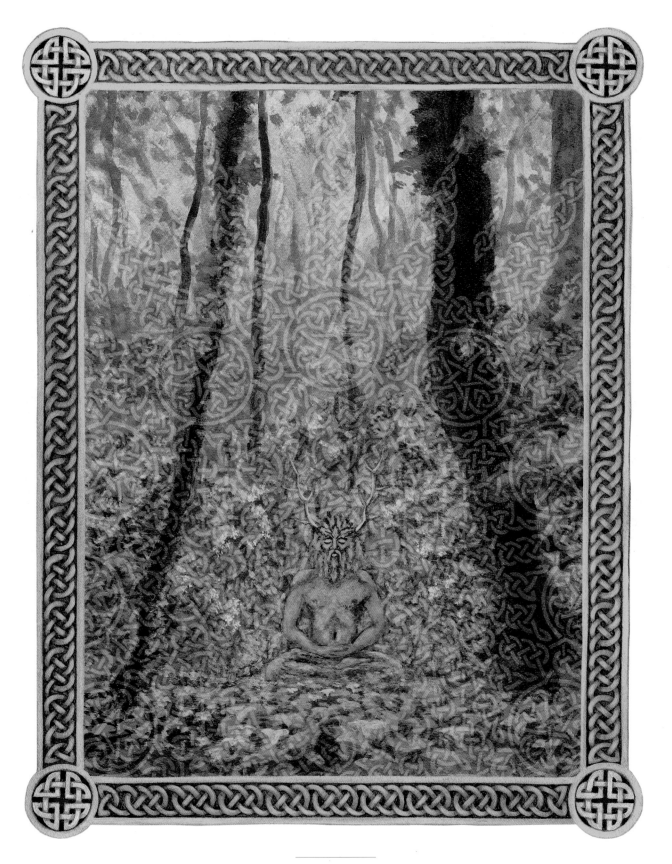

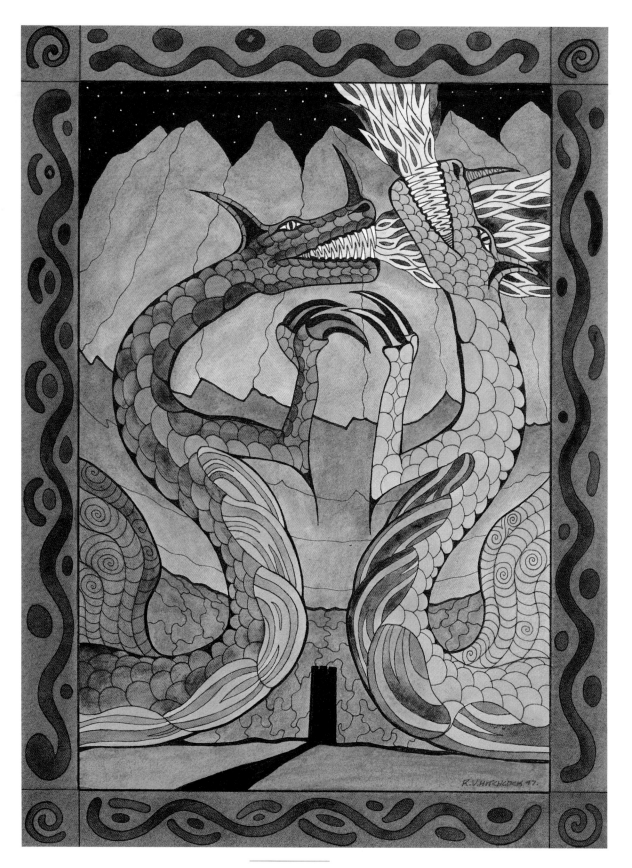

Roger Hitchcock

ESSEX, UK

MY ART is inspired by and connected to the pagan esoteric traditions of Britain and the rest of Europe. These traditions are ageless, and are more relevant now than ever before. They honour the earth and all her creatures, and teach us that all life is sacred. I work in many diverse areas, but my main influences are ancient British Celtic mythology, the Druid tradition and ancient European Shamanism. To many it would seem only fragments of these ways remain. I believe through art and poetry these fragments become larger and form a whole.

I am following my own Druidic path within the Druid tradition. I hope my work reflects the mystery of the Druid tradition. My ideas and inspiration come from meditations, inner pictures, intuition and emotion. The messages of our ancestors and ancient god and goddess forces are particularly interesting to me as an artist.

I see Celtic art as a tree that is ever growing and changing, in the spirit of the Celtic legacy itself. Like the ancient Celts it is tangible and intangible at the same time.

OPPOSITE
VORTIGERN'S
TOWER

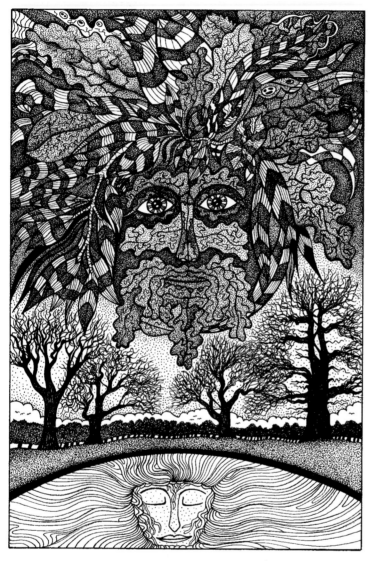

THE GREEN MAN

I am the God of the green wood

I come with the Goddess in spring

I am the God of the green wood

I am home to all living things

I ask you humans to leave me

So I may grow wild and free

I am the God of the green wood

The oldest of men is but a child to me

I am the lord of the wild wood

In a clearing I stand still

I am the God of the green wood

All trees grow to my will

I am the spirit of the forest

I answer the Goddess's call

I am the ancient one

Here in the beginning

And growing after the fall.

LEFT **THE GODDESS AND THE GREEN MAN** OPPOSITE **JACK O'GREEN**

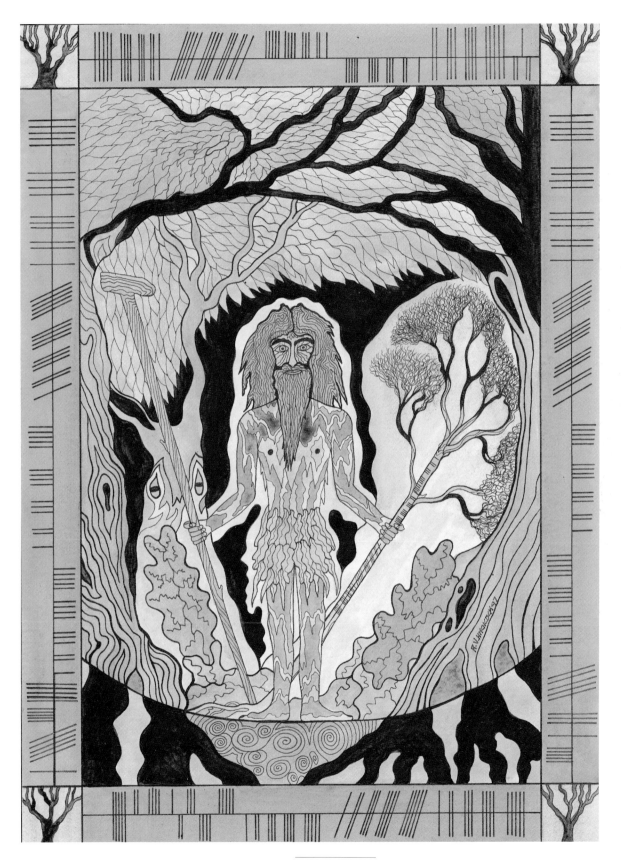

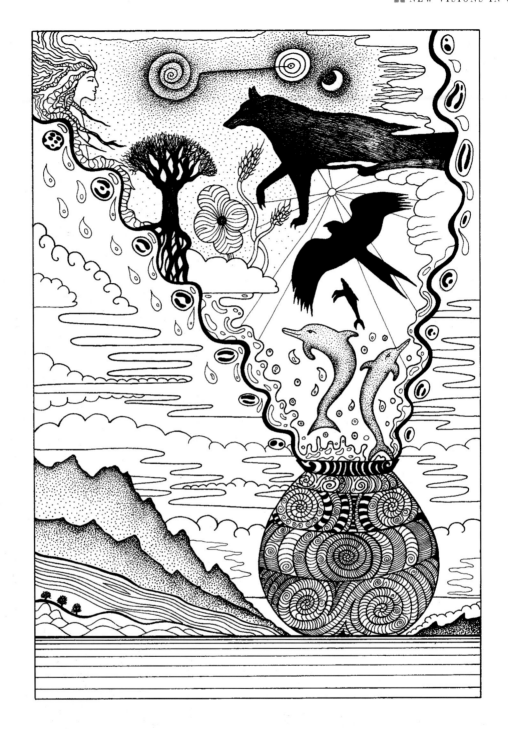

ABOVE
CERRIDWEN'S
CAULDRON
OPPOSITE
MERLIN'S
MIRROR

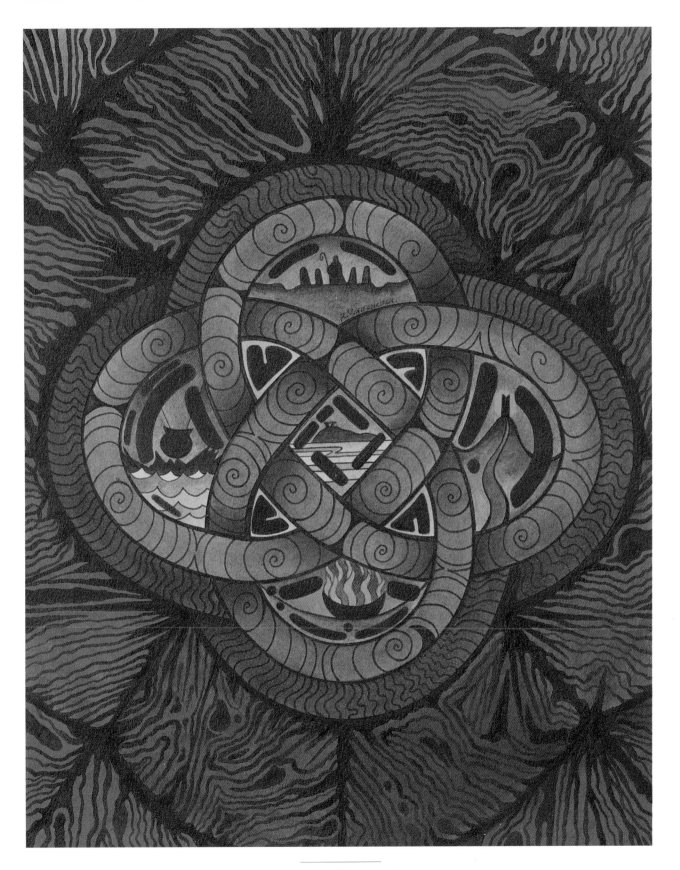

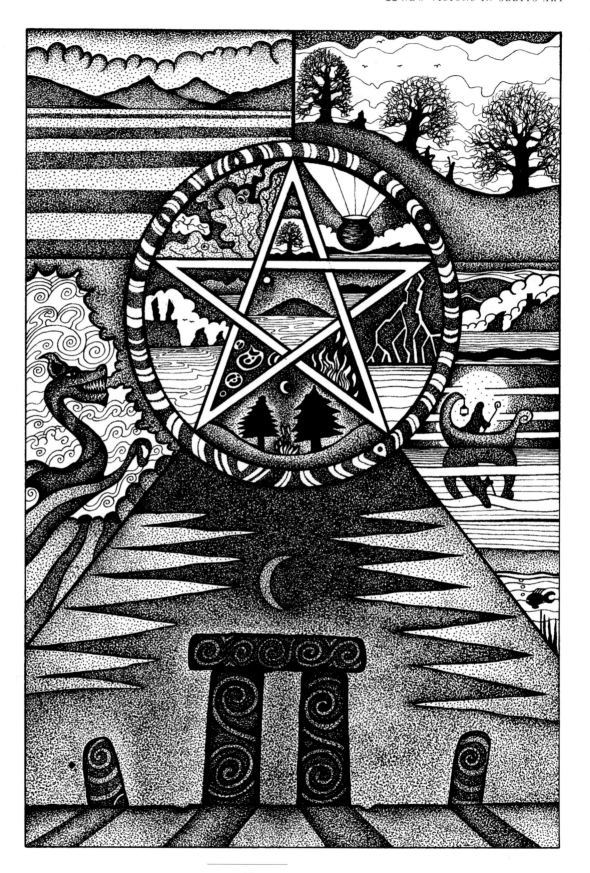

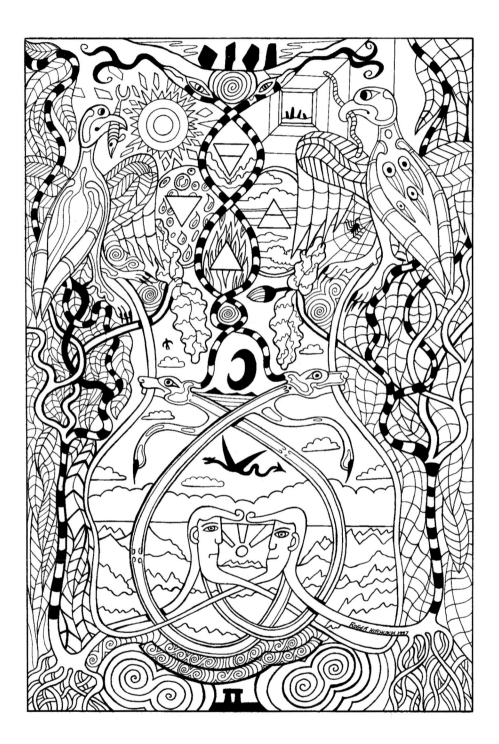

OPPOSITE
THE UNION
RIGHT THE
BIRDS OF
RHIANNON

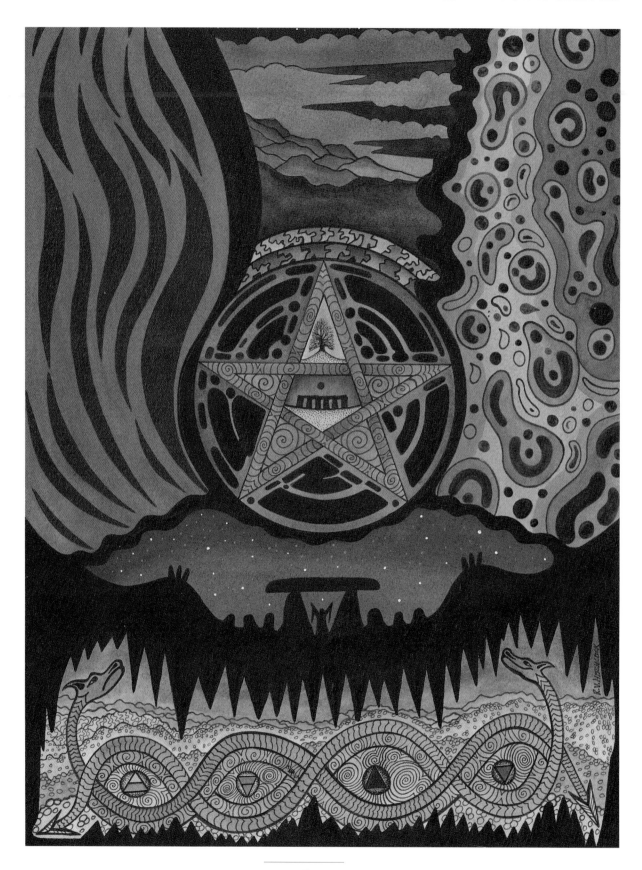

OPPOSITE
THE
ELEMENTS
RIGHT EPONA

Sara McMurray-Day

KILLARGUE, CO. LEITRIM, IRELAND

THE INTRICATE interlacings of the Celtic knots, the circular windings of the spirals, and the never-ending pathways of the maze patterns are what inspire me. I had been searching for this inspiration for years, but it had always eluded me. Then, on a visit to the ancient isle of Avalon in 1994, I came across a copy of *Celtic Borders and Decoration* by Courtney Davis (Blandford, 1992). The images which adorned these pages awakened something in me that sent my mind racing in all directions; a call from the three birds of Rhiannon. Having been an avid artist throughout school, I used to believe I would always be involved in this area somehow. On leaving school, however, working first for a printer and later for a reprographic company, my artwork began to take a backward step as other commitments and daily life took prominence. My once vivid imagination became clouded, and, unable to find the right direction in which to take my talent, frustration led me to let it slide altogether. I made a few half-hearted attempts during those years, but as more time passed, it became increasingly difficult to recapture the inspirations I could once so readily transfer to a blank sheet of paper.

Myths and folklore hold a great fascination for me, the stories of the legendary heroes of Britain and Ireland more so than those of other

OPPOSITE
AIR

71

cultures. Having been born and raised in the Celtic region of Demetia (present-day Dyfed, west Wales), local tales of Pwyll, Rhiannon and King Arthur abounded, and I felt a special bond with them from a young age. On acquiring my first book by Courtney Davis, and studying the ancient artform he has so beautifully brought forward to the twentieth century, I began to experiment with Celtic design. Before long I found myself spending hours charting the simplest of knots onto paper and being constantly amazed at the multitude of patterns which would form from entwining them. The required discipline was a challenge, but as the methods became clearer, it proved to be more therapeutic than I could have ever imagined. As a young artist, I felt unable to detail my work effectively. Learning how to create Celtic patterns taught me it is possible to turn the simplest of designs into elaborate illustrations by incorporating complementary borderwork.

In October 1994, I completed 'Pwyll, Prince of Dyfed'. The excitement of finally discovering the direction in which I could take my artwork was overwhelming, and before long every spare moment was spent rediscovering the many tales of the Celtic world. To begin with I used watercolour, the only paint medium I had ever worked with, but as my confidence grew I began to experiment with gouache and acrylics. One cold winter's morning 'Arthur' was created in black ink. Astounded at the subtle definition this simplest of tools could produce, I eagerly laid out a fresh sheet of paper and 'Morganna', and then 'Myrddin', the first two pictures to be included in this collection, were born of the same idea. These images were reproduced into greeting cards with the help of a local printer, and were well received by local craft outlets in the area. More were created and the quality of my work steadily improved.

In April 1996, on impulse, my husband and I moved from Wales to Ireland. From idea to reality took less than three months. We now live and work from a little cottage in the heart of the North Leitrim Glens, my studio being a space beneath one of the living-room windows. There is no spare room we can convert, so there is a constant clutter of materials and books filling every conceivable space. Life ambles along at a far slower pace now, and inspiration surrounds me like a warm blanket

when ... side our back door, the
breath... realm of Faerie, where
lie the... immortal souls of Erin.
I have... our time here, and all
have l...

... natural world so close
at ha... t of that one chance
encou... its current path. It is a
path f...

Check Out Receipt

... Central
...7-536-5400
http://www.bpl.org/

Wednesday, Mar 6 2013 1:57PM

... 39999037868930
... Celtic beasts : animal motifs and z
... design in Celtic art
... Book
... 27/2013

... 39999014635898
... The pageant of medieval art and lif
... Book
... 03/27/2013

... 39999036672?68
... New visions in Celtic art : the mod
... tradition
... Book
... 03/27/2013

... items: 3

... You!

CAER
IBORMEITH

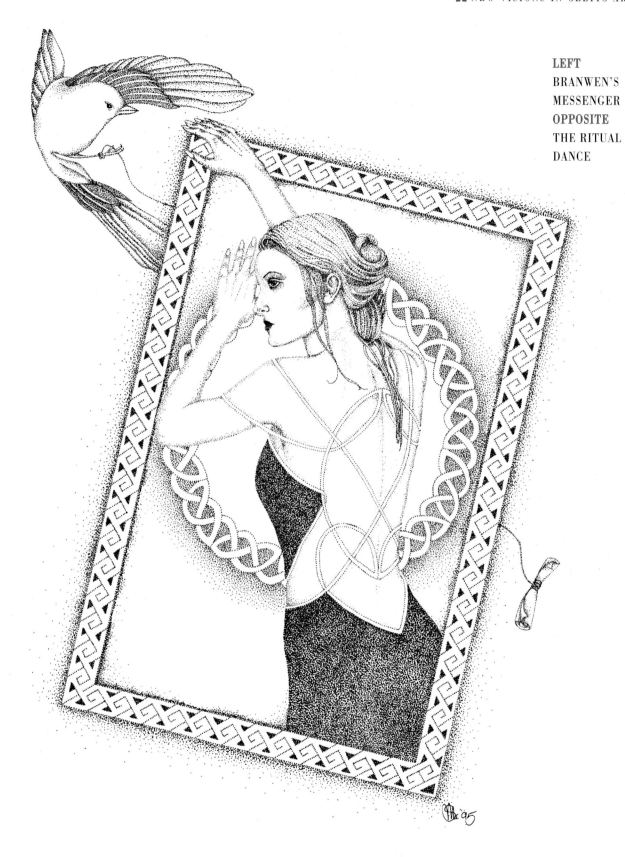

LEFT
BRANWEN'S
MESSENGER
OPPOSITE
THE RITUAL
DANCE

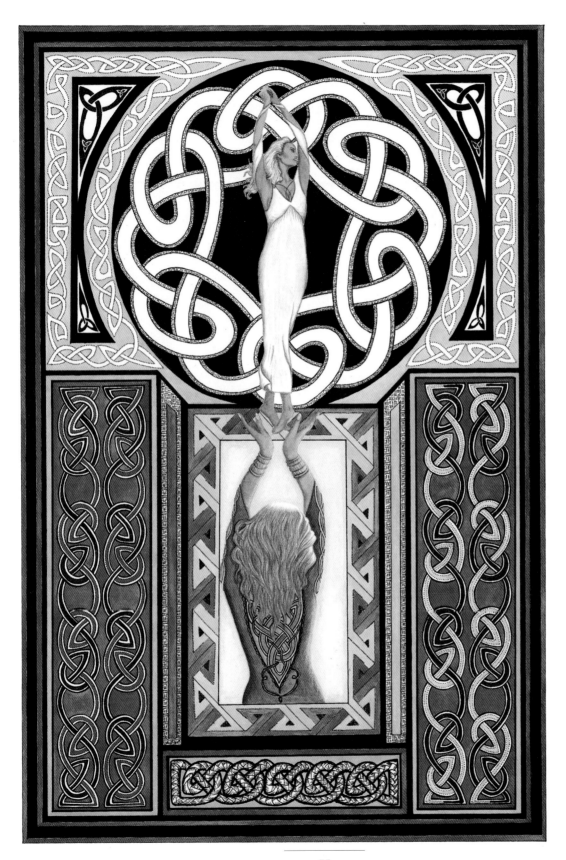

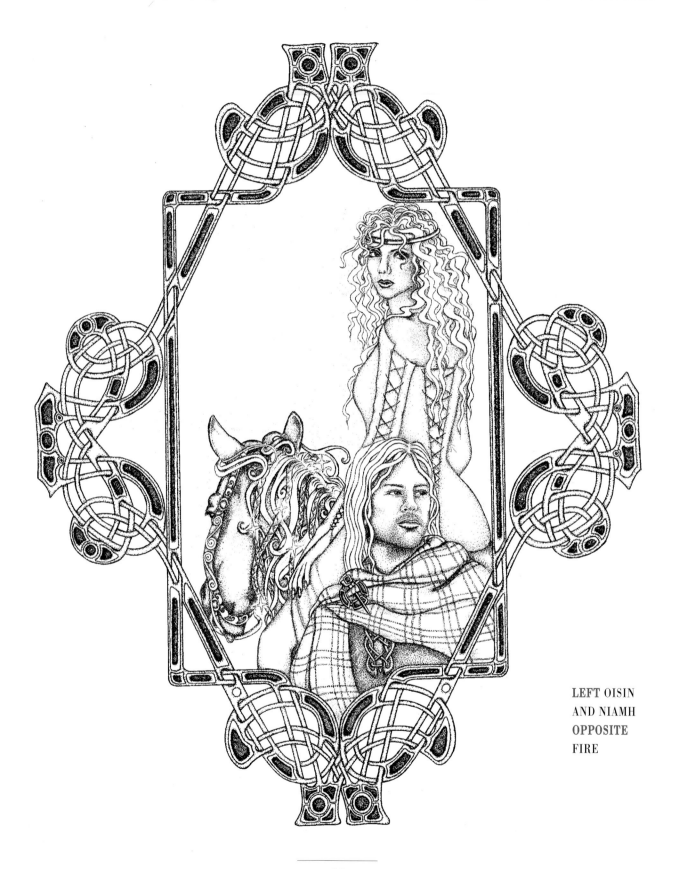

LEFT OISIN
AND NIAMH
OPPOSITE
FIRE

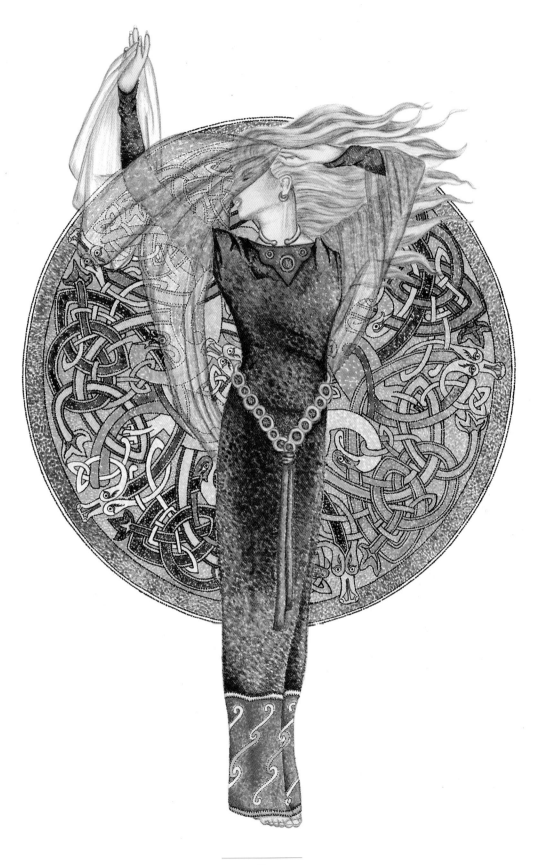

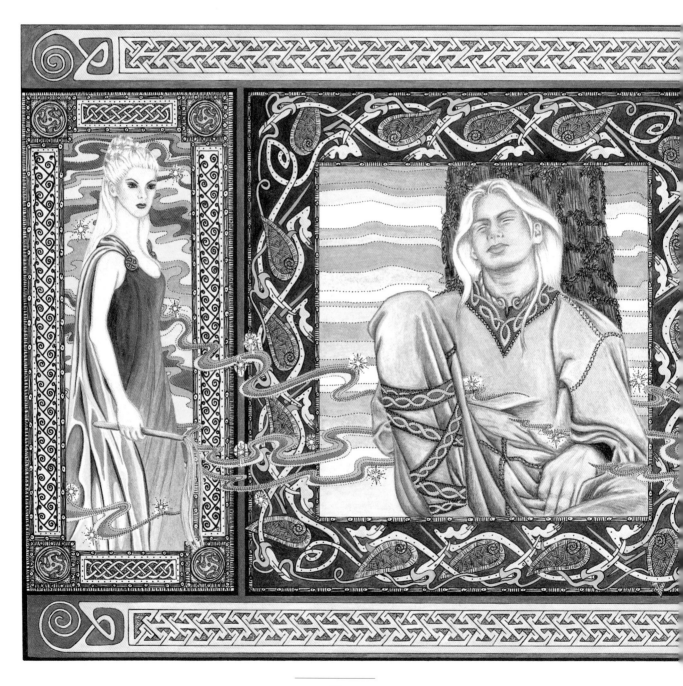

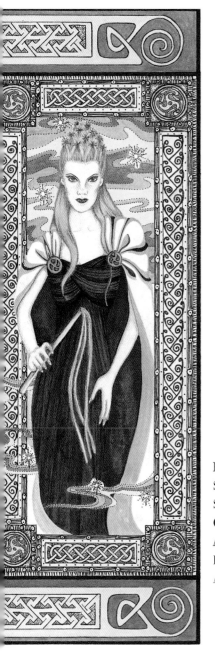

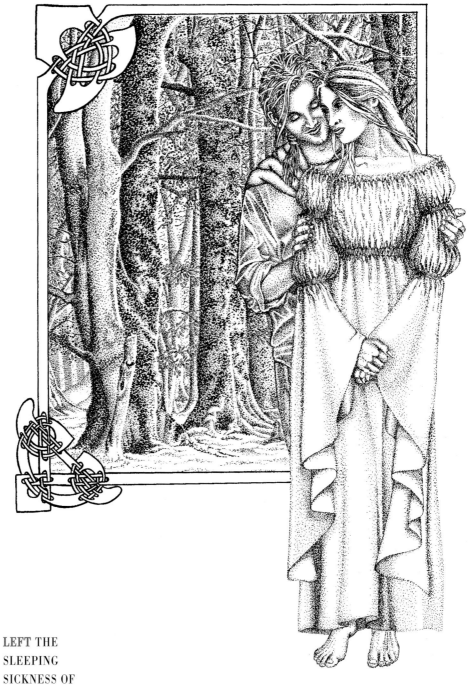

LEFT THE
SLEEPING
SICKNESS OF
CUCHULAINN
ABOVE
DIARMUID
AND GRAINNE

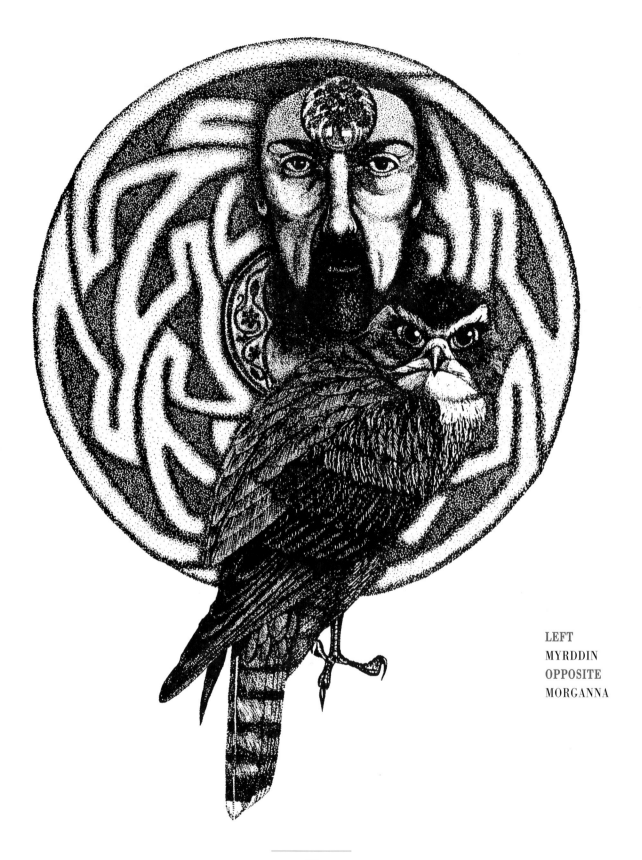

LEFT
MYRDDIN
OPPOSITE
MORGANNA

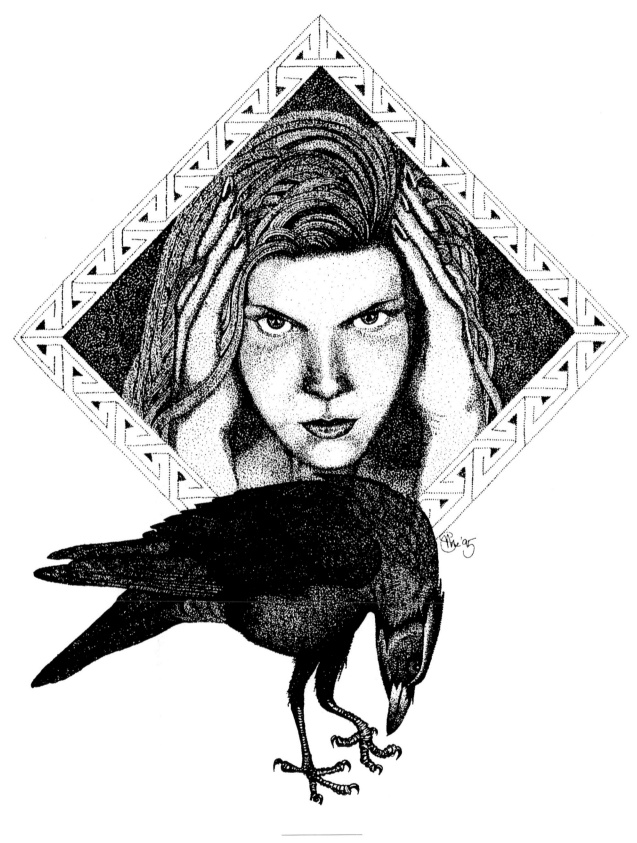

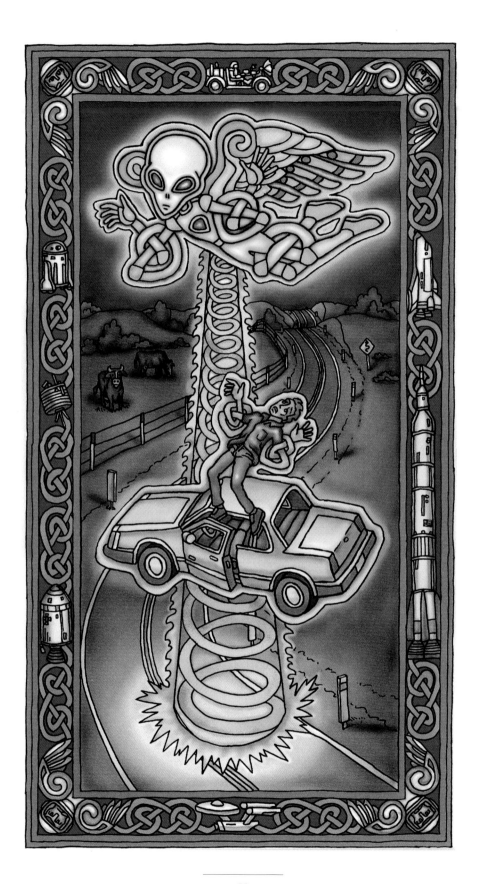

Steve O'Loughlin

LOS ANGELES, CALIFORNIA, USA

M Y FASCINATION with Celtic art has been going for 20 years. It began in college in a medieval art history class, when the instructor showed a slide of the Chi-Rho page from the *Book of Kells*. Then he showed some details and explained their origins. He said that the people who had created this intricate artwork were considered backward and primitive, and that it served as a sort of television for their otherwise dreary lives. This was my introduction to Celtic art. Until then I had no idea of its existence. Being of Irish descent, I was immediately attracted to it and I began copying examples from George Bain's instructional book, *Celtic Art – The Methods of Construction* (Macmillan, 1951).

Growing up in California has left me with minimal contact with the Celtic world. Searching out information where I can, and travelling to Ireland on a couple of occasions, I am a self-confessed Celtophile, devouring all things Celtic – books, music and history. I've even gone so far as playing the tin whistle for the last five years! It's just something that hooked me and that I've given into, and it has given me a dynamic artistic outlet to talk about my experiences.

After I graduated from art school (MFA, San Francisco Art Institute, 1988) I then moved to Los Angeles, where I began to

OPPOSITE
ALIEN ANGEL
ABDUCTION

83

develop my Celtic skills seriously. I learned the basics of Celtic art, such as interlace, spirals and key patterns. As my confidence grew, I incorporated new elements into the Celtic designs. African, Aztec and Islamic art influences are all reflected in my work and, by combining these with Celtic art, I have developed new variations and rhythms.

Another aspect of my art is the social commentary that runs through it. This is a carry-over from earlier work, in which I often made social observations. The interlace figures of Celtic art have become a marvellous story-telling device. Interlacing contemporary figures together, they act out modern dramas and situations. The Los Angeles riots, freeway culture, shopping malls, multicultural neighbourhoods and even television are some of the themes I've touched upon. I show my paintings and sculptures at various art shows throughout California as part of my continuing effort to reflect society. At my exhibitions, I have found a common thread running throughout the questions my viewers ask: 'What do the knotted-up arms and legs mean?' My answer continues to develop, so here's the latest attempt: First of all, what is a knot? It's a bond that hold things together. Therefore the knotted limbs symbolize their spiritual bonding in the experience of living, much like the invisible bonds of a family.

One of the great attractions of Celtic art is its spiritual quality. This is of course tied up with the magical pagan symbols and illuminated manuscripts. How do we relate to them many centuries after their heyday? Obviously they are beautiful and the eye delights in chasing around their sophisticated rhythms. Beneath the visual appeal are symbols that point towards the spiritual cycles. Spirals and spinning lines echo life's continuing patterns of growth, decline and rebirth. When I apply these abstract patterns to an airliner, it deviates from a realistic representation of a jet full of people, giving a more profound look at one of our mechanical wonders.

Recently I started working in carved wood. I cut my drawings quickly into wood and fill them with coloured stains. This new medium forces me to simplify and clarify my images. It also creates a marvellous 3-D line quality. 'Releasing Angels' was one of my first large wooden

pieces, showing protecting angels hovering above a city scape. Many angels had been showing up in my work, and as I investigated them further I came across the alien–angel connection. In my carved wood piece 'Alien Angel Abduction' I comment on this connection and contemporary outer space myths.

The Aztec solar disc inspired me to create my painting 'Celtic Sun Dial'. I wanted to pay homage to the life-giving power of the sun and how it sustains the different life forms on our planet. 'Crucifix', an oil painting, was inspired by the large medieval wooden crosses that I saw on a trip to Italy; they were so radiant that I had to create my own Celtic version.

My paintings 'Freewayman' and 'Wheel God' both deal with the car culture in which we live here in Los Angeles. The running figure in 'Freewayman' is entangled in an endless ribbon of traffic. I wanted to express the caught-in-traffic anxiety we live with. 'Wheel God' is my modern interpretation of the ancient Celtic wheel god figures I have come across during my continuing research into Celtic art history.

'Remote Control' is my tribute to the excesses of television. This is especially true here in Los Angeles. The Celtic deity Cernunnos, the horned god, is emerging from the television set with his antlers full of cables, televisions and speakers.

'The Los Angeles Riots' conveys my impressions of the social breakdown that took place here in Los Angeles in 1992. I used the twisted figures of Celtic art to express the tension of the riots. 'Peace Mandala' came as a healing gesture after the riots. In it African, Asian, Hispanic and Western cultures are all represented separately, then blended together.

Celtic art has been around for thousands of years and continues to evolve in our fast-paced world. I see my own work as a continuation of Celtic art, not just a glimpse into the past, but a vehicle for the future. I hope my insights will inspire other artists to push the boundaries of Celtic art.

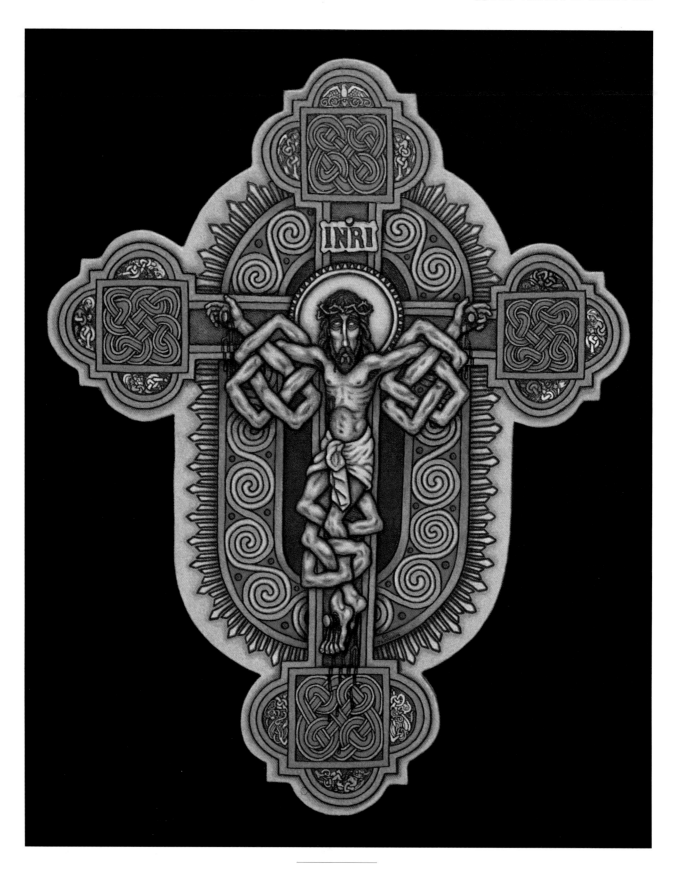

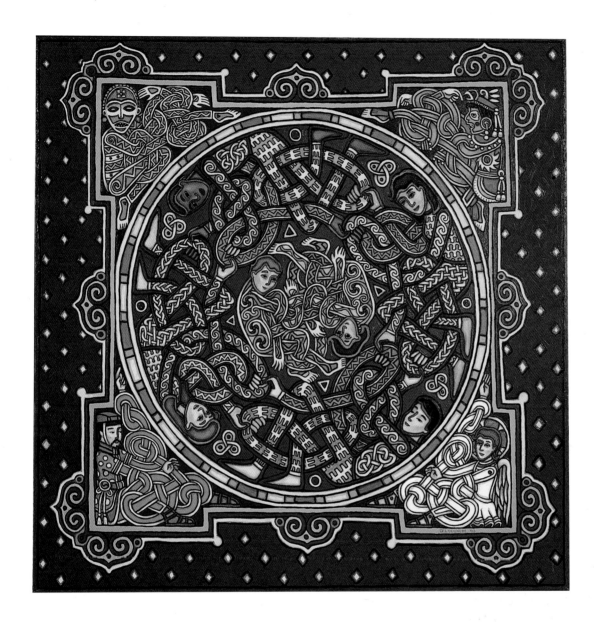

OPPOSITE
CRUCIFIX
ABOVE
PEACE
MANDALA

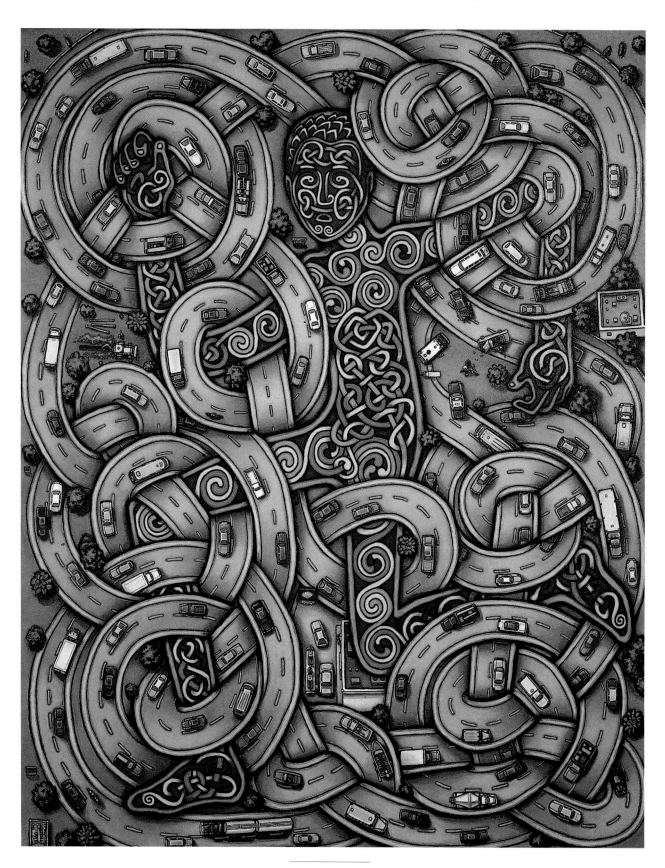

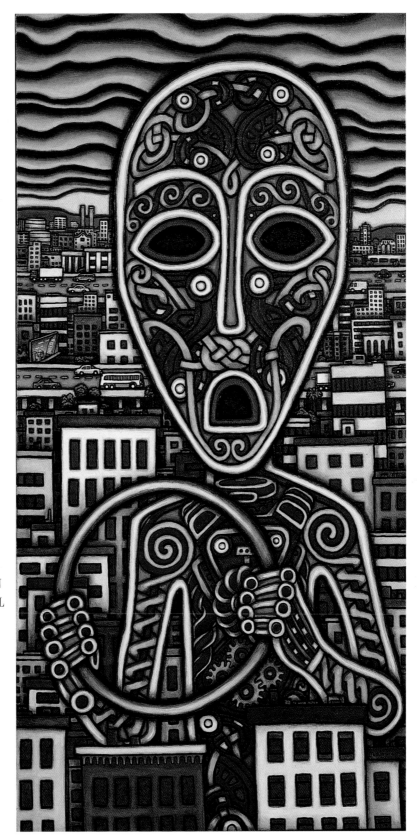

OPPOSITE
FREEWAYMAN
RIGHT **WHEEL**
GOD

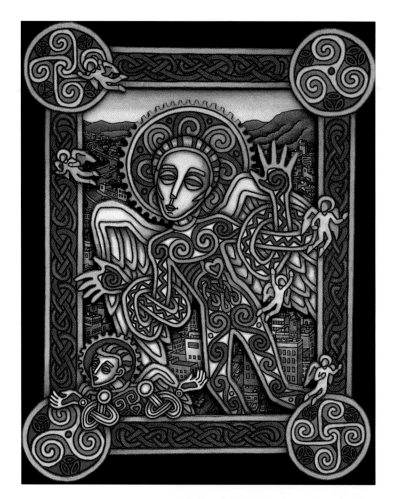

LEFT
RELEASING
ANGELS
BELOW THE
LOS ANGELES
RIOTS
OPPOSITE
REMOTE
CONTROL

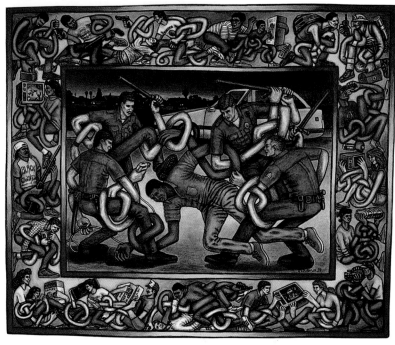

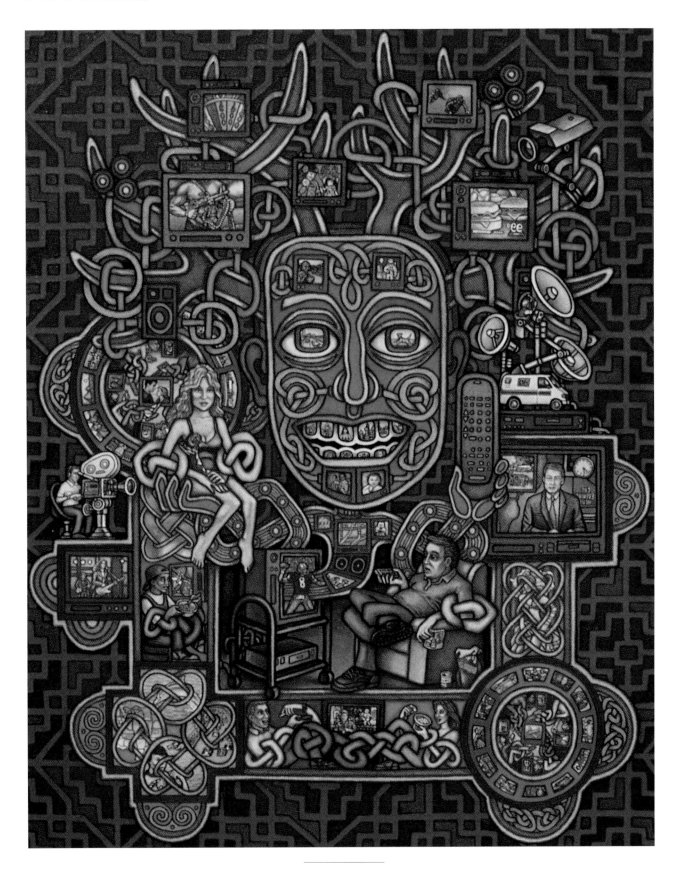

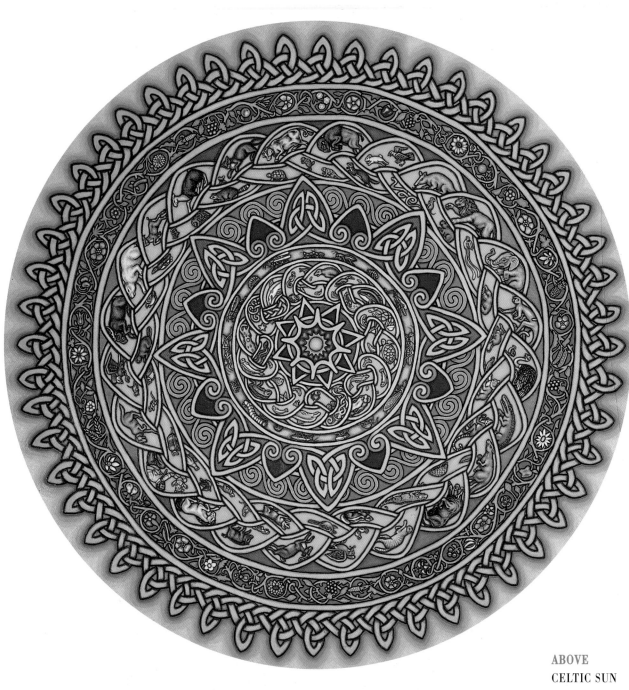

ABOVE
CELTIC SUN
DIAL
OPPOSITE
FLOWING
TRAFFIC

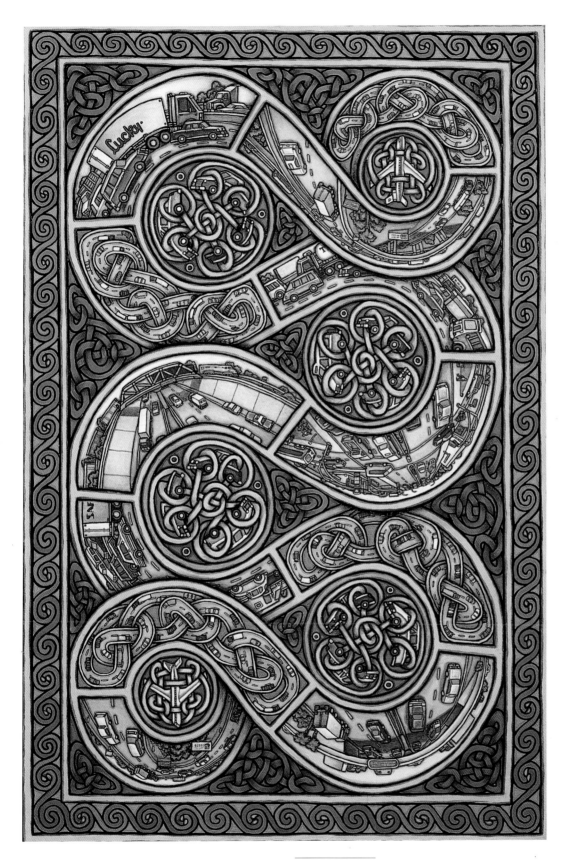

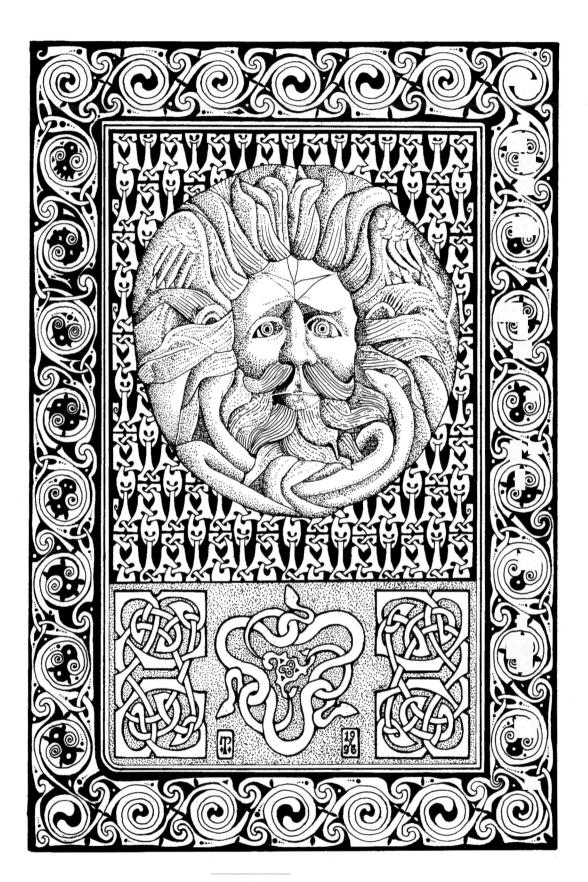

Nigel Pennick

CAMBRIDGE, UK

MY FIRST introduction to Celtic art, as far as I can remember, was seeing open pages of the *Lindisfarne Gospels* in the British Museum as a child. I was fascinated by the awesome intricacy of the fine lines that swept back and forth, interlacing with others as they went. I marvelled at the human ingenuity that could design such a fantastic work of art, and the patient skills of the scribe. A few years later in Ireland, I was shown some high crosses, which reinforced my interest in Celtic art in general, and in particular in interlaced patterns. Then I began to experiment with drawings of interlacings and the geometrical patterns that underlie them. Later, I made studies of ancient Celtic stones, primarily in Wales and Ireland, but also in England, Scotland and the old Celtic heartlands of southern Germany. In recent years, most of my Celtic drawings have been to illustrate my books on the landscape and traditions of northern Europe.

OPPOSITE THE GORGONEION FROM THE TYMPANUM OF THE TEMPLE OF SULIS MINERVA AT BATH

Celtic art has come down to us in an unbroken chain from ancient Europe that started more than 2700 years ago. Celtic art has never remained static, but has developed continuously in tune with the age in which it was made. Each succeeding generation has produced its own versions of this artistic current, handing them on to the next when the time came. From this age-old European culture comes an ancient

abstract art that provides a meaningful alternative to the experimental abstractions of the twentieth-century avant-garde. Celtic art is meaningful because it is rooted in the natural world, both in its visible structure and in its unseen geometry. By linking the here-and-now with the eternal, it crystallizes the essence of the infinite cosmos in material form.

In my Celtic art I have two aims. One is to illustrate in line the form and styles of ancient Celtic artefacts, such as Celtic crosses. The other is to express the essence of the north European spiritual and philosophical tradition by using the underlying symbolic principles of Celtic art. I see my own contribution to Celtic art as a contemporary manifestation of my ancestral heritage. Now, as ever, there is a dynamic, living spirit in all things Celtic which maintains its relevance to the present age as much as it did in times past. ▓

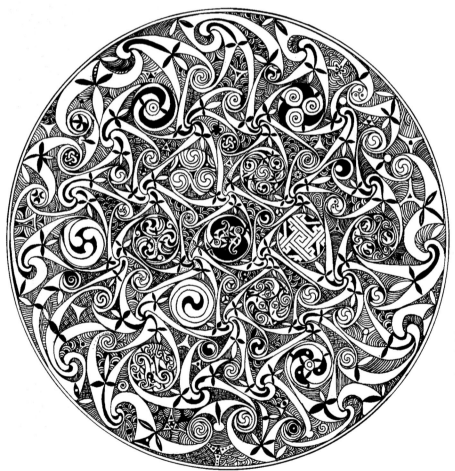

LEFT CELTIC WHEEL OPPOSITE THE ARCHE-TYPAL CELTIC CROSS AS SUNWHEEL

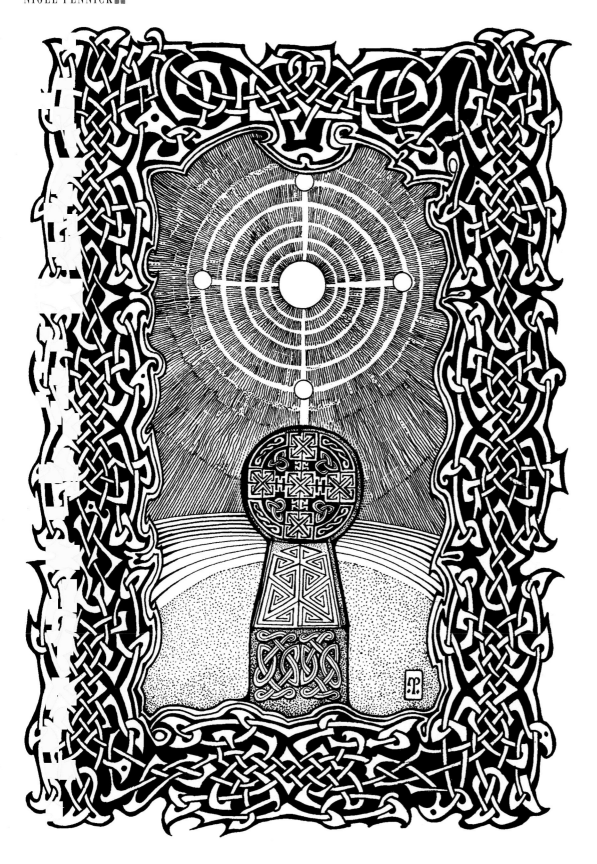

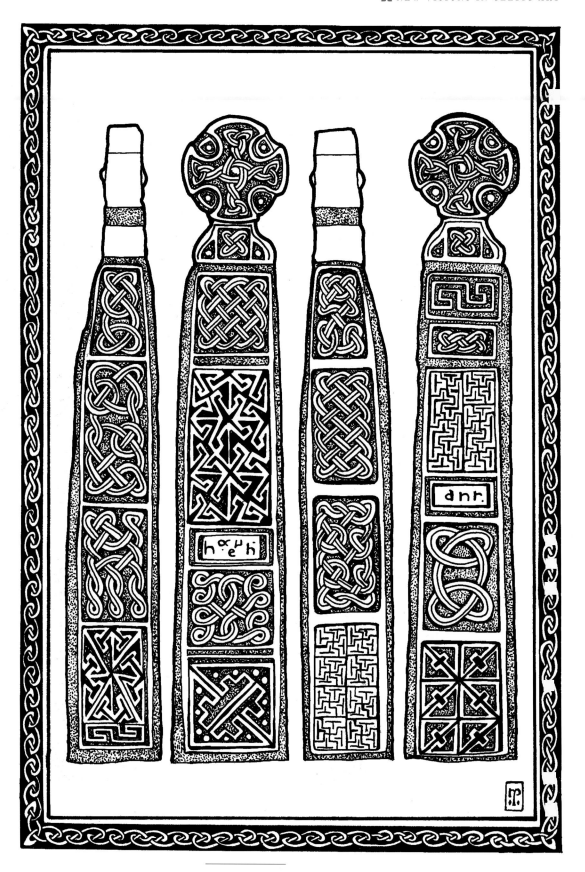

OPPOSITE
**THE NEVERN
CROSS** RIGHT
**FRAGMENTS
OF CROSSES
FROM KIRK
CONCHAN,
ISLE OF MAN**

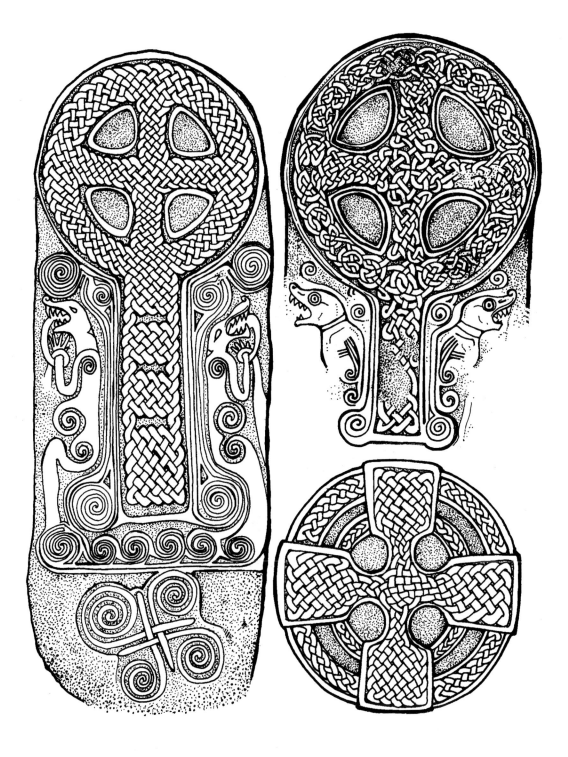

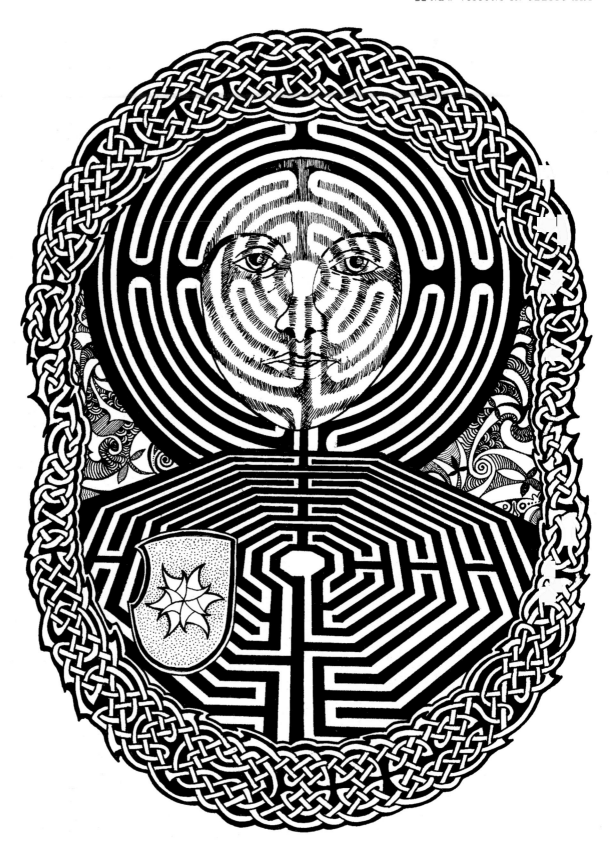

OPPOSITE
THE GODDESS
IN THE
LABYRINTH II
RIGHT THE
COSMIC AXIS

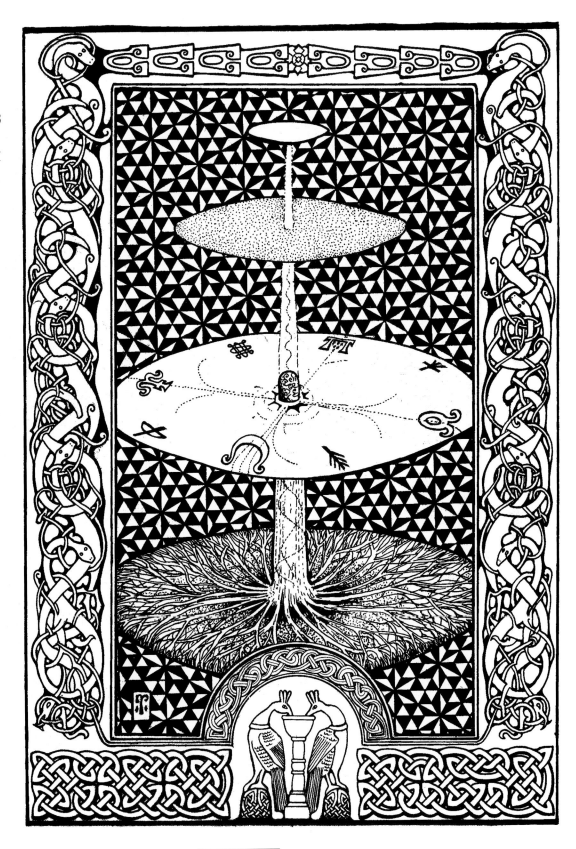

101

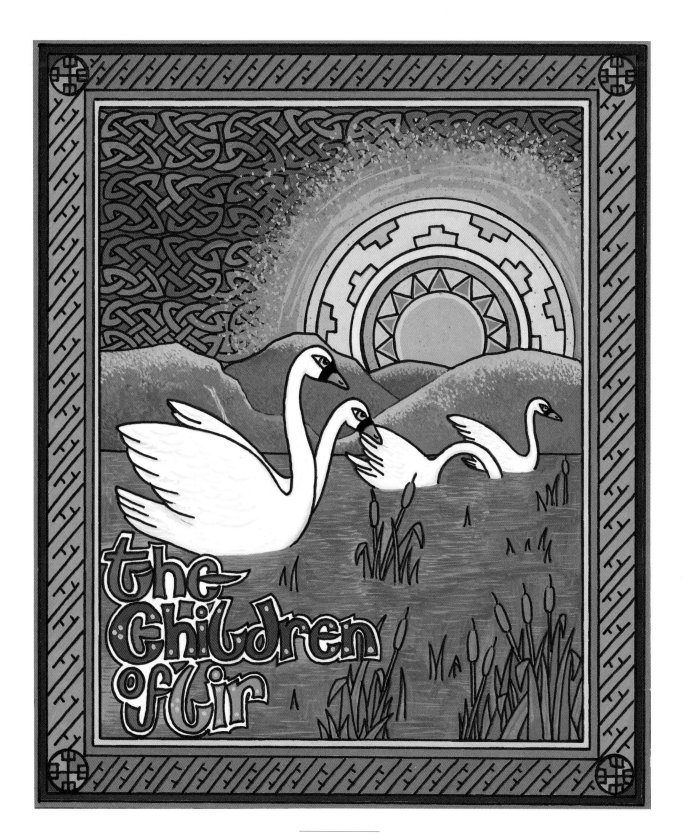

Simon Rouse

CAMBRIDGE, UK

SOME OF the patterns in these illustrations have been around for hundreds, even thousands, of years, and have been used by artists and craftsworkers down the centuries in a variety of media. I came upon them 15 years ago via a different artform: music. Through the music of the great Breton musician Alan Stivell I entered the world of the Celts, a realm of gods and men, heroes and lovers, battles and magical beasts; the world of nature and of *Annwn*, the Celtic Otherworld. It became, and has remained, a world of inspiration and is the foundation upon which I create my art.

Inspiration is the most important aspect of the work I do; without it, the long hours spent drawing and refining the knotwork, spirals, key patterns and zoomorphics, would mean nothing. Music continues to play a part in this inspirational process, from Robin Williamson to Led Zeppelin; music that has the feel of the Celtic spirit about it, and which will transport me to other places and other times, providing a soundtrack for the pictures I produce. The printed word is important too; gifted poets like Pamela Constantine, writers and teachers such as Sir George Trevelyan, and the film-maker John Boorman, all provide, through their creative gifts, places where I can journey to in search of inspiration and a guiding light. The works of fellow artists and painters,

OPPOSITE
THE CHILDREN
OF LIR

too numerous to mention and not all from the Celtic tradition, are constant companions, aiding me in the transformation from blank paper to finished illustration.

Travelling to sacred sites has given me a new vision into the way in which our ancestors viewed the world around us. Callanish, Castlerigg, New Grange and Glastonbury are just four of the many places I feel privileged to have visited, and I have attempted to bring back with me to the drawing board a sense of the power such sites as these convey to the modern pilgrim.

The natural landscape of the British Isles, in particular the areas that remain predominantly Celtic in character, the Highlands and Islands of Scotland, the mountains of Wales, are important to me also. It is in these high places that I can truly experience the wonder of the natural world, for which the ancient Celts had such affinity. Each tree, stone and river has its own spirit and being among them allows me to sense my own place in the universe. I try to reflect this harmony in my paintings.

The great illuminated manuscripts of Celtic art are a wonder to me. Their design and execution are unparalleled, their makers the most gifted individuals. They show me the perfect balance that can be attained when heart and mind are one. It is something to which I can aspire, although whether I will ever get there I cannot say. The experience of the journey, however, will be worthwhile in itself. ❖

OPPOSITE
IONA

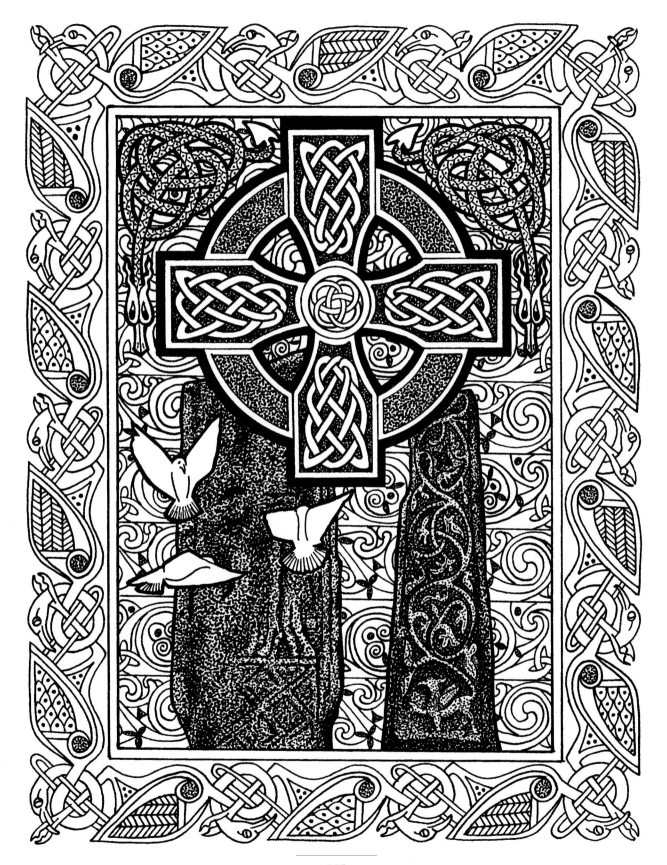

LEFT CARPET
PAGE
OPPOSITE
CLAS
MYRDDIN

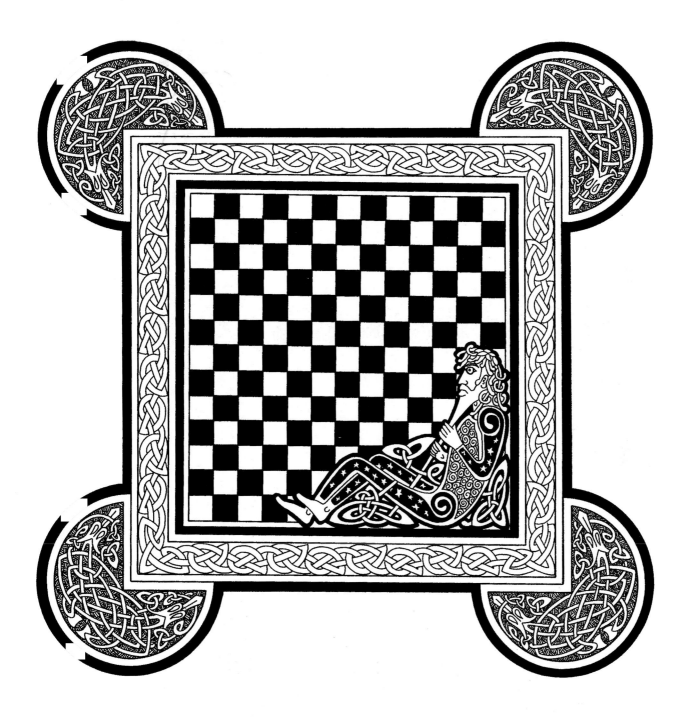

LEFT GATE-
WAY TO THE
OTHERWORLD
ABOVE ST
COLUMBA
OPPOSITE
EPONA'S
STONE

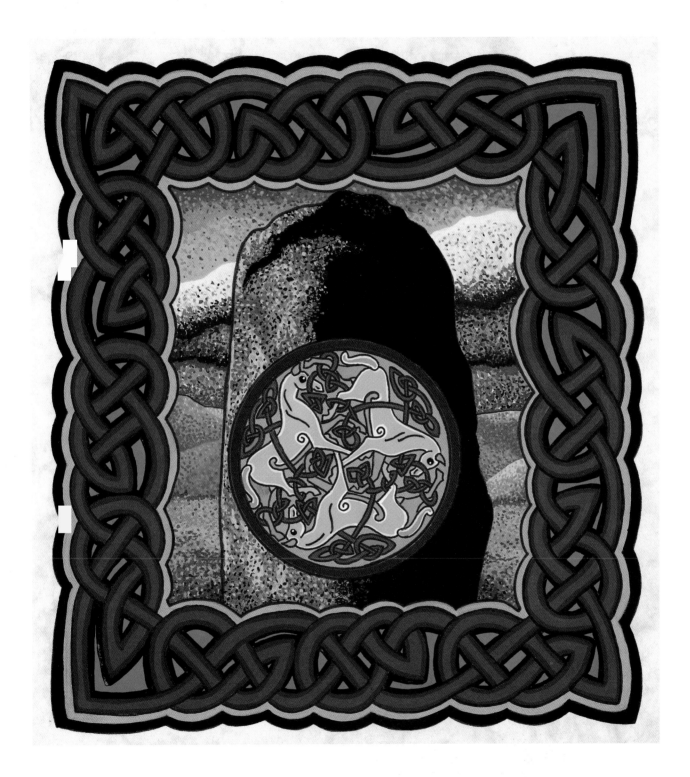

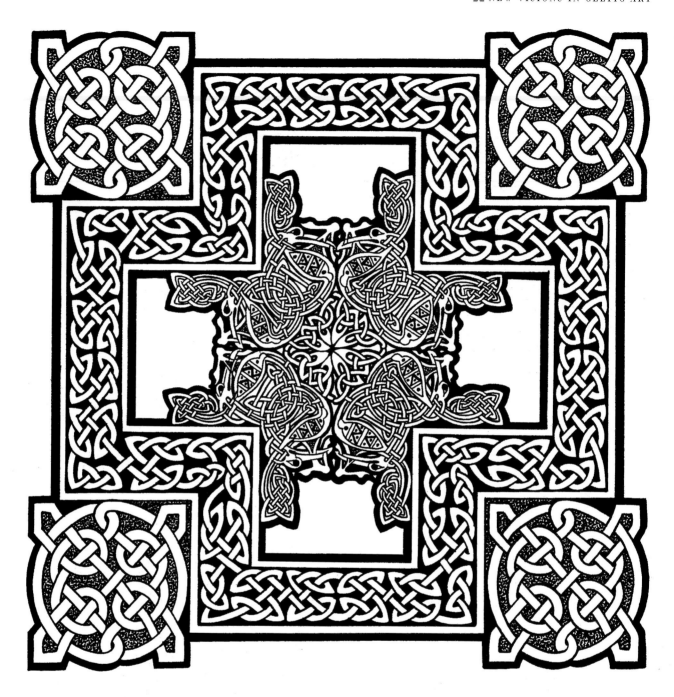

ABOVE **INNER**
TEMPLE
OPPOSITE
SPIRIT OF
IONA

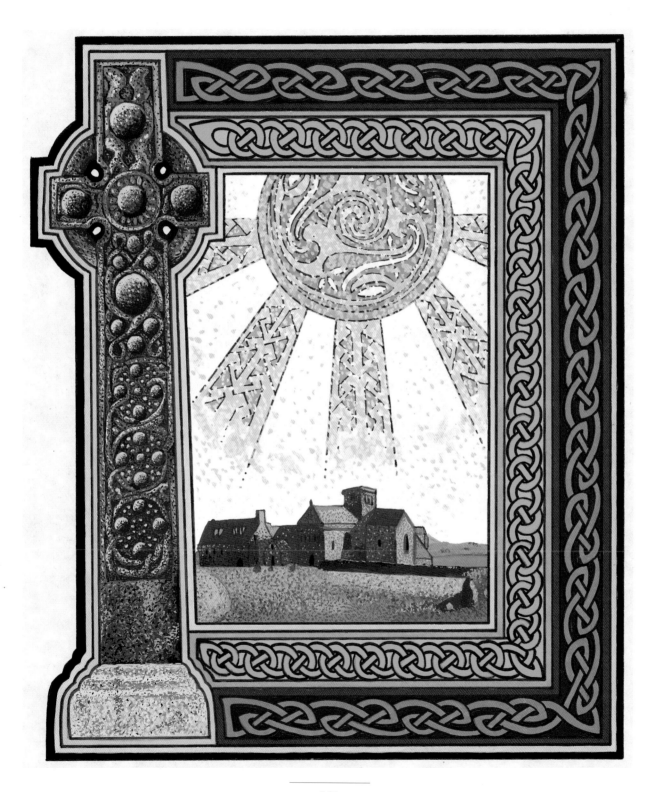

BELOW ST
KEVIN AT
GLENDALOUGH
OPPOSITE
CELTIC CROSS

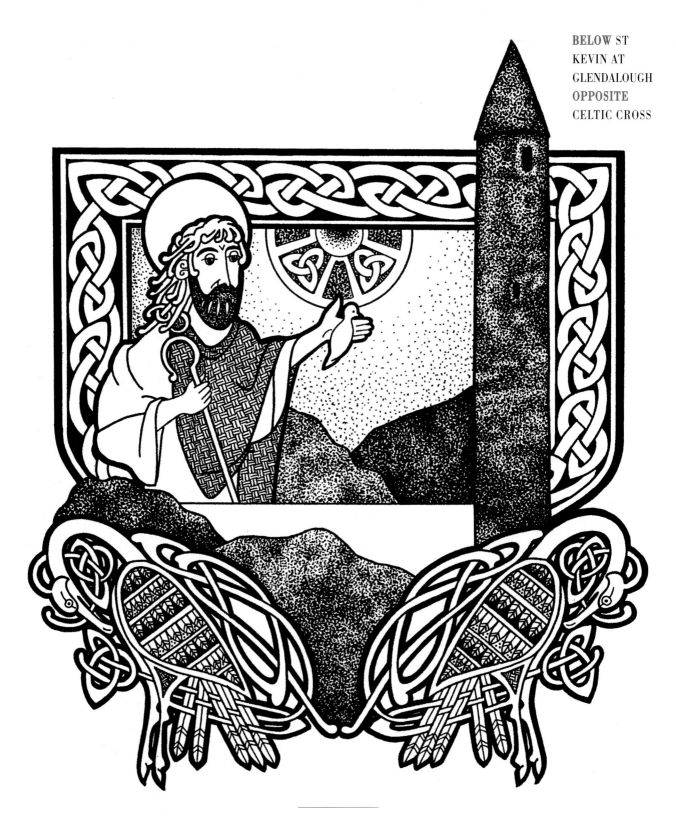

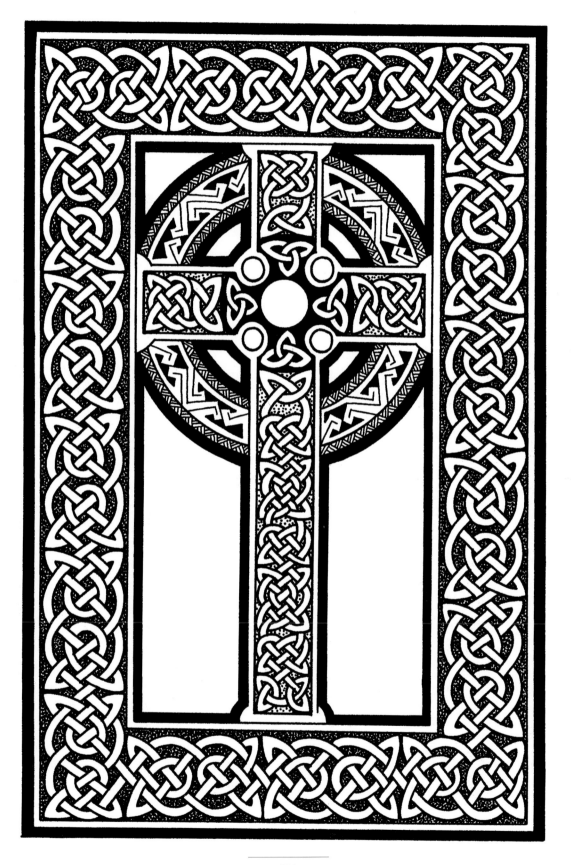

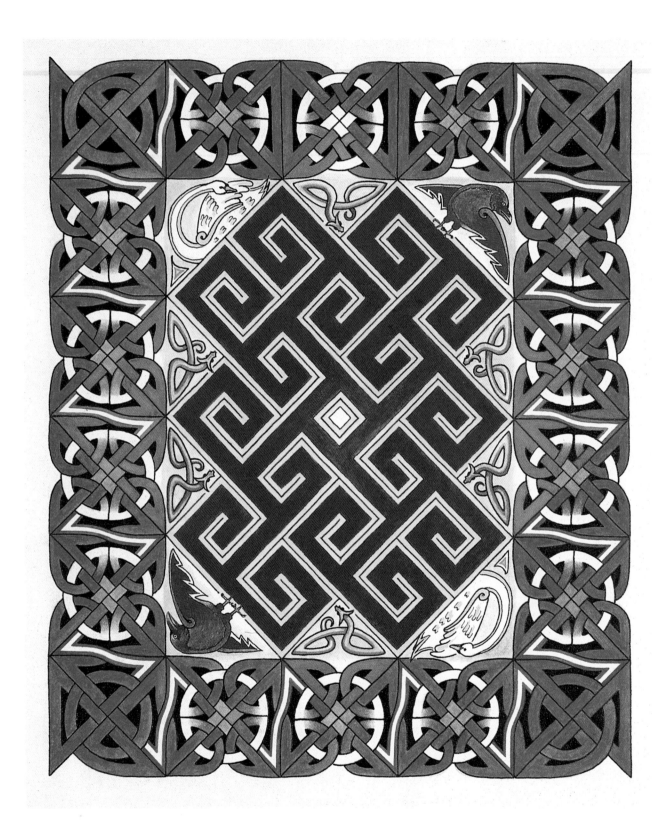

Mike Terrett

PRESTON, LANCASHIRE, UK

I HAVE ALWAYS had a natural affinity for drawing and painting. After leaving art college with a degree back in 1984, I virtually gave up practising art until I came into contact with the Celtic tradition many years later in 1993. All the work presented here has been produced since this time, over a period of about five years. Celtic art fuses many areas of personal fascination relating to art, nature and science. This artform has the ability to express an entire range of possibilities and worlds. I feel it is essentially (but not exclusively) magical in nature, reflecting an underlying reality – one which is not necessarily comfortable or familiar. Celtic art often conveys the natural world as we normally perceive it, but at the same time it travels beneath the surface, where creation is sensed as an endless flux and interaction of energy. The distinctive patterning of Celtic art has grown from and reflects this intuitive experience of life.

When working on a design I follow my instincts, adapting a traditional motif or two in an original way until a pattern begins to grow. By giving the work careful attention it then begins to unfold and reveal itself. Colour schemes are sometimes suggested spontaneously within the imagination. It's important not to fix a design too soon. Usually, I only know what it's all about at the end!

OPPOSITE
LIGHT OF THE
UNDERWORLD

Among the pieces submitted for this collection, the design for 'Sun Wheel' may be used as a rough calendar and contains symbols for the four elements/seasons, which also correspond to the traditional cross-quarter festivals. The positions of the solstices and equinoxes are each marked by a whitish cross embedded in the knotwork at the cardinal points. The irresistible sword of dawn and spring cuts through the knotwork to begin and end each cycle. Thus the circle is one turn of an open spiral.

While 'Sun Wheel' is about understanding by way of illumination, 'Lunar Wheel' is about sensing through darkness and reflected light. Thirteen huge waves encircle pictures of the moon's key phases, with the dark or hidden phase represented at the centre of the design. The outer border is a maze pathway divided into 52 triangles (4 x 13). This is also the number of weeks in a year, and this design can also be used as a rough calendar.

'Star Wheel' forms a set with 'Sun Wheel' and 'Lunar Wheel', and was inspired by a study of galaxies, stars and nebulae, together with the primal power of the spiral and serpent. It is about creation; the birth of number uttered through its many spiral patterns. The star bursts are coloured in relation to observed star colours and the spectrum of visible light. They appear only where four spiral knots come together.

'Lugh's Shield' grew from the centre outwards, and represents the energies of the sun. There are many geometrical relationships to be found within this piece. The unit or panel used repeatedly here is a combination of knot and border which leaves very little empty space. It is the same as that found on an old Pictish stone – the Strathmartin Stone in Angus, Scotland. Only after this design was finished did I discover that in Irish myth one of the god Lugh's magical objects was indeed a shield. If you look at this painting from a distance you will see another pattern. Incidentally, the knotwork path forms one continuous line and so the whole design is really just a convoluted circle!

'The Game of Chess' wasn't planned but grew from experimenting with maze and keypatterns. Beneath the surface-play of colour and light that delineates the chessboard is a maze with a continuous path.

The border of chess players was added later and illustrates the interaction of energies both over and under the table.

'Light of the Underworld' grew from the knotwork border inwards, and conveys a search for inner knowledge and meaning. The illumined maze is an adaptation of one found in the *Book of Lindisfarne*. Both the swan and the raven have links with the Celtic Otherworld, as documented in several myths and legends. Red and green serpents are the guardians of the maze, at the same time echoing its writhing and cunning passageways. The whole pattern shows the nature of energies at play beneath the surface world.

'Crystal Star' is based on an original hexagonal maze unit repeated or translated several times to form an overall star pattern. The pathways connect by way of light and colour, rather than by more obvious physical means.

'Maze of Light' (I and II) have a similar property to 'Lugh's Shield', in that they can literally be viewed in several ways. Close up, the interconnecting pathways are in a state of ordered flux. The angled ones suggest the subtle dispelling and fracturing of light as well as the energies of expansion and contraction. If you step back from the design, other inherent patterns are revealed.

The advertising poster for a Celtic art course which I run displays letters which are a combination of original treatments and adaptations of traditional initials from the illuminated manuscripts. There is a subtle narrative running through these letters which indicates the potential for humour and storytelling through Celtic art.

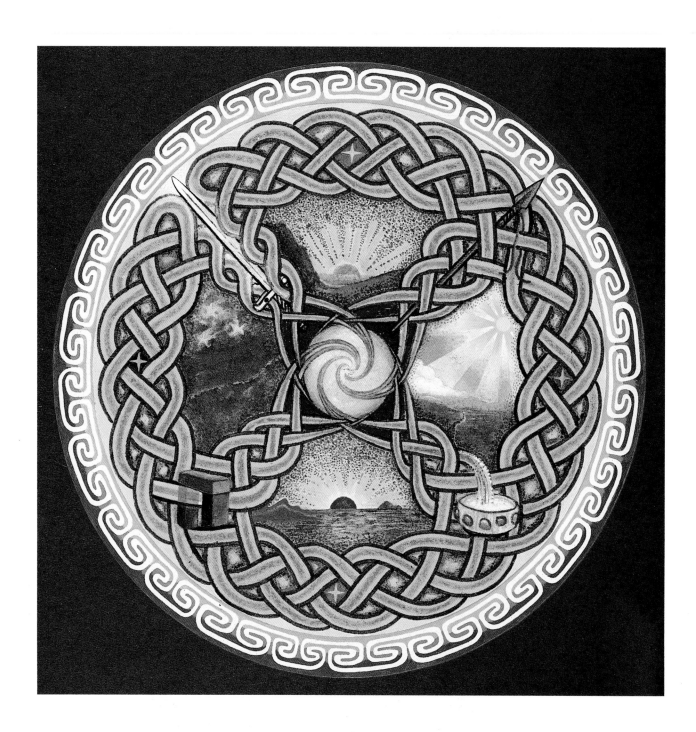

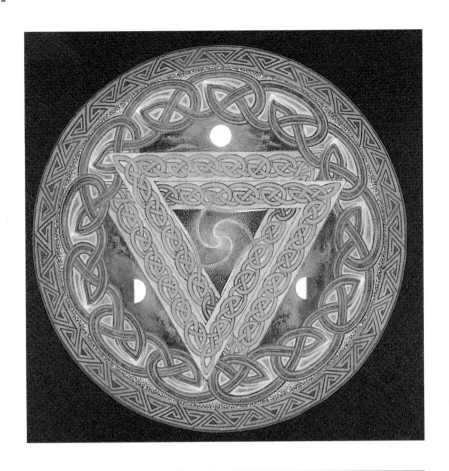

OPPOSITE
SUN WHEEL
ABOVE LUNAR
WHEEL RIGHT
STAR WHEEL

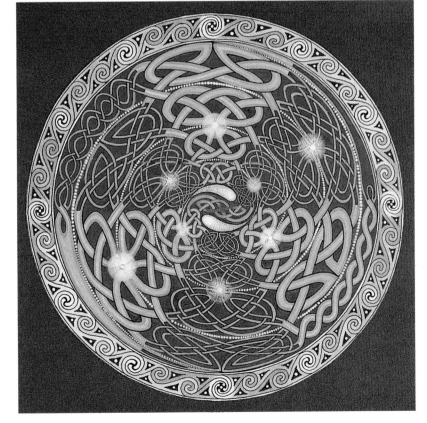

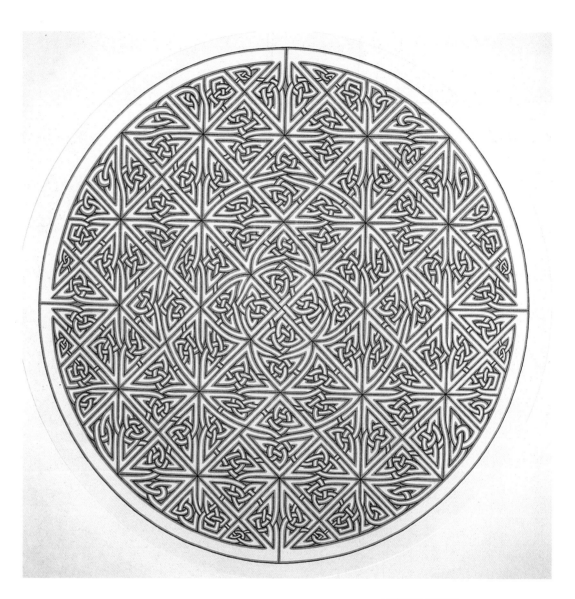

ABOVE LUGH'S
SHIELD
OPPOSITE
THE GAME OF
CHESS

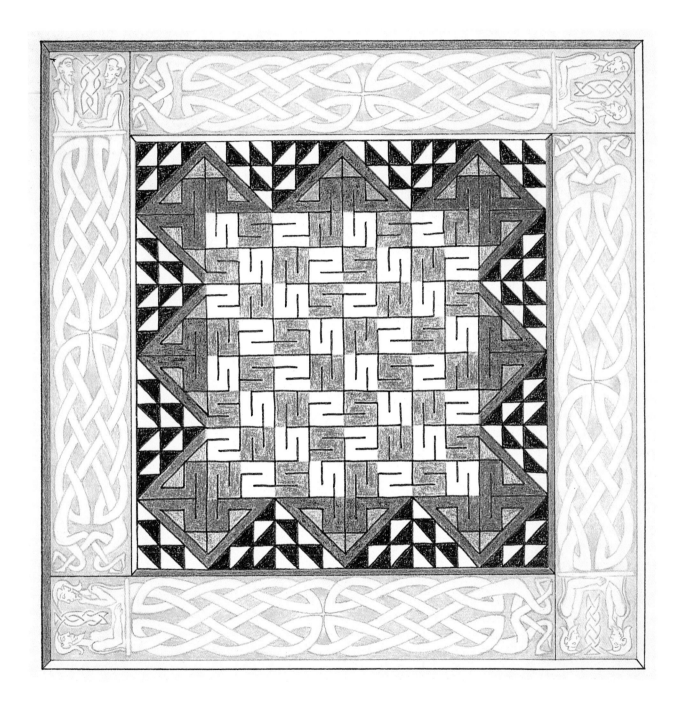

CELTIC ART

A D.I.Y. GUIDE

WHEN?

WHERE?

MORE·INFO?

© M. TERRETT 1997

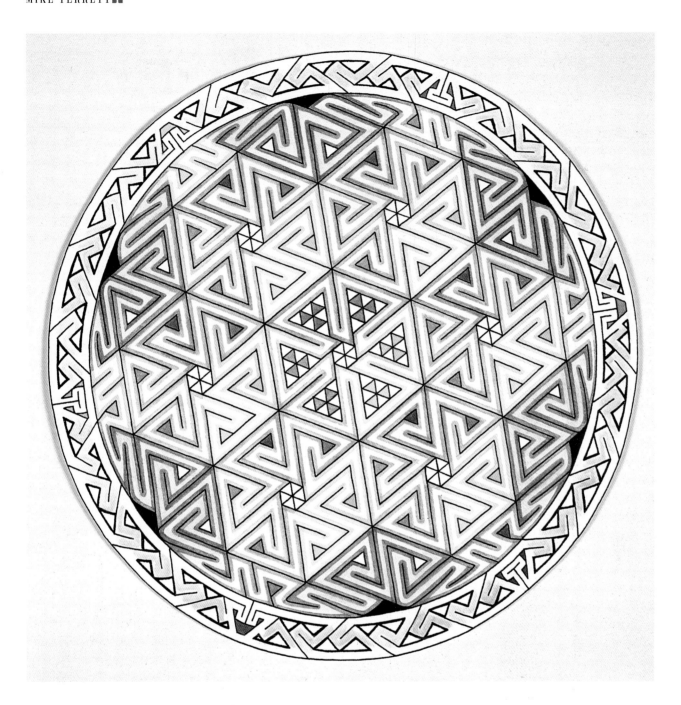

OPPOSITE
POSTER FOR
CELTIC ART
COURSE
ABOVE
CRYSTAL
STAR

LEFT MAZE OF
LIGHT I
BELOW MAZE
OF LIGHT II

Further information

IF YOU have a particular interest in the work of any of the artists and illustrators included in this book, you may contact them with any enquiries as follows:

John C. Baker
100 St Andrews Road, Bridport, Dorset, DT6 3BL, UK

Jen Delyth
Mail order catalogue address: Box 302, 3701 Geary Boulevard,
San Francisco, CA94118, USA, Tel: (415) 668-6968,
Fax: (415) 668-2321
Inquiries only: Lower Mill Cottage, Hill End, Llangennith, Gower,
Swansea, West Glamorgan, SA3 1HU, UK
Web page: www.kelticdesigns.com
email: Info@kelticdesigns.com

Nigel Pennick
142 Pheasant Rise, Bar Hill, Cambridge, CB3 8SD, UK

Simon Rouse
The Light of Celtica, 43 Water Lane, Oakington, Cambridge,
CB4 5AL, UK

The following artists can be contacted via the publisher:

Chris Down, Fred Hageneder, Roger Vincent Hitchcock,
Sara McMurray-Day, Mike Terrett

> c/o Editorial Department
> Blandford imprint
> Cassell plc
> Wellington House
> 125 Strand
> London WC2R 0BB
> UK

David James founded the magazine *Celtic Connections* in 1992, which now enjoys an enthusiastic readership from all over the world.

Celtic Connections is available on annual subscription basis from:
David James, Sycamore Cottage, Waddon, Portesham,
Nr Weymouth, Dorset, DT3 4ER, UK.

Subscription rates are UK £7.00, Europe £9.50, rest of world £11.50 (UK sterling only). It is also supplied wholesale to shops and centres in the UK.
email: celtic.connections@wdi.co.uk

In the USA *Celtic Connections* is available from:
New Leaf Distributing Co., Thornton Road, Lithia Springs, Georgia,
GA 30122-1557, Tel: (770) 948-7845

Index of picture titles

BOSTON PUBLIC LIBRARY

3 9999 03667 216 8

BOSTON PUBLIC LIBRARY